JOURNEYS TO ABSTRACTION 3

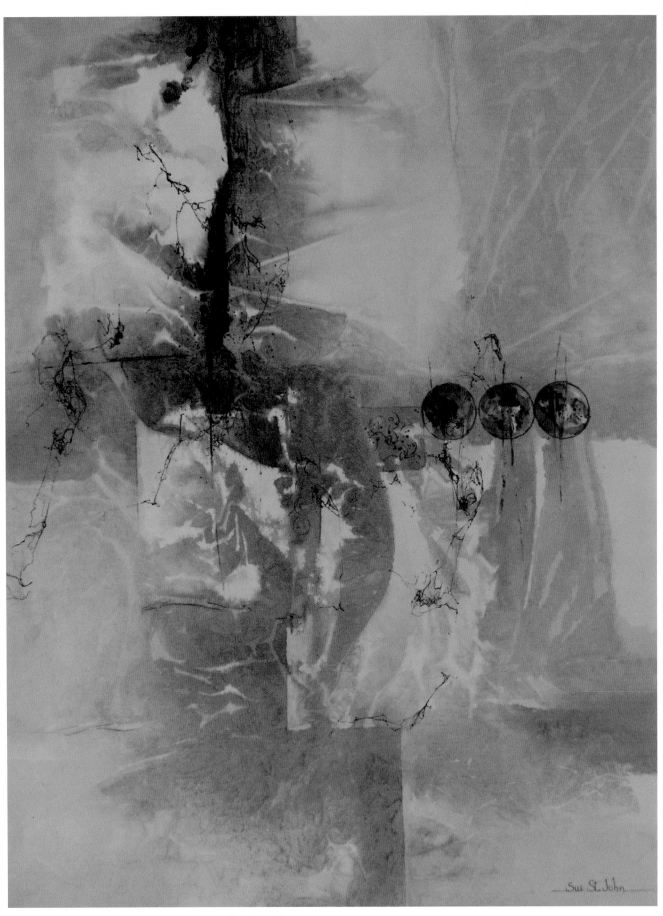

Emerge by Sue St. John, AWS. Mixed media, 30"x 22"

JOURNEYS TO ABSTRACTION 3

**100 More Contemporary Paintings
and Their Secrets Revealed**

Sue St. John

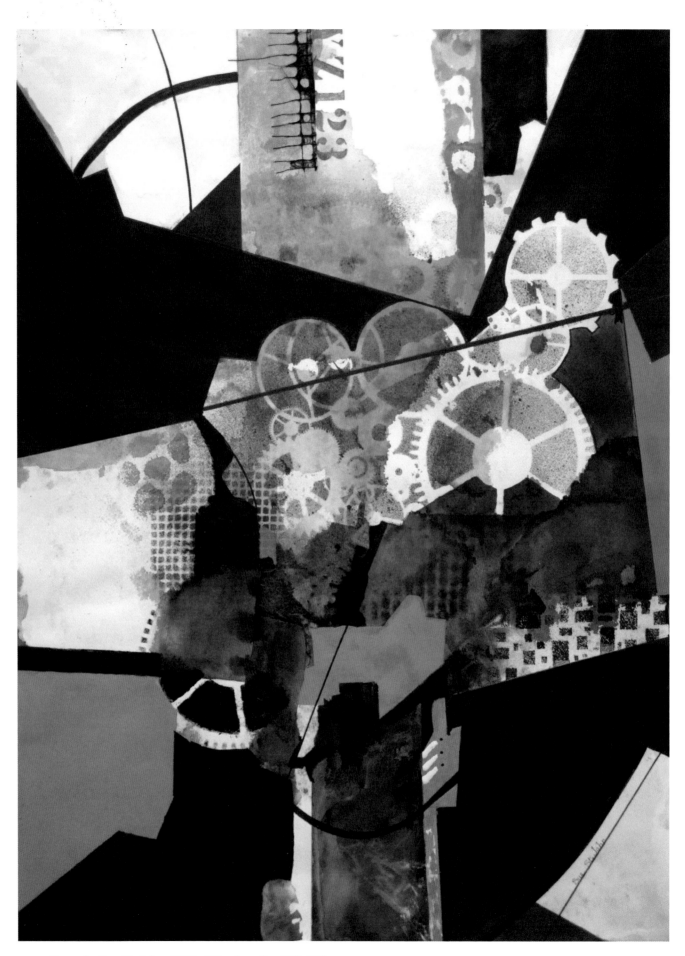

Gears by Sue St. John, AWS. Mixed media, 30"x 22"

CONTENTS

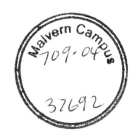

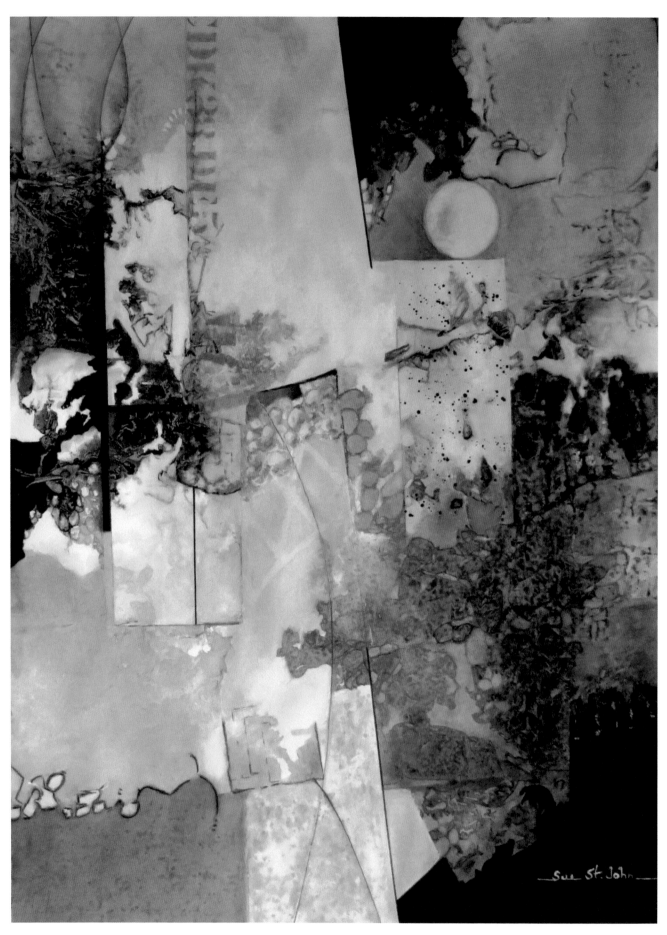

Wonderment by Sue St. John, AWS. Mixed media, 30"x 22"

REALISM TO ABSTRACTION

From the Renaissance to about the middle of the 19th century, western art focused on realism—on presenting the world as it actually exists. Much of the art world was wholly focused on techniques for most accurately portraying the world, with the goal of giving the viewer not only the impression of art not only imitating reality, but of art actually being reality. Logic and perspective were of utmost importance.

In the middle of the 19th century, this began to change. Western artists felt they needed to develop new techniques and styles in order to keep up with and accurately represent the drastic changes going on in the world, changes not only of technology and science but also of philosophy. Artists therefore began experimenting with what we now know as abstract art. Abstract art isn't about portraying reality accurately. In fact, when viewing a piece of abstract art, it may sometimes be difficult to know what the subject of the piece is!

Instead of focusing on logic and perspective, abstract art uses imagery to convey an experience or emotion. Sometimes, abstract art uses imagery drawn from reality so that the viewer can recognize the inspiration behind a subject. An image in abstract art may obviously be, for example, a tree—or it may be just recognizable as having been inspired by a tree—or it may not look like a tree at all, and yet have something of the smooth line of a trunk or the way the sun makes the shadows of leaves play upon the ground. It may, in other words, evoke treeness (for example); it may even give the viewer a sense of familiarity he or she may not understand, but which derives originally from knowledge from childhood of trees. . . .

This is, of course, assuming that the piece of abstract art was ultimately derived from reality, which is not always the case. Abstract art exists on a continuum from *almost realism* to *complete abstractionism*. Examples of art that are often completely abstract are geometric abstraction (which uses geometric shapes such as rectangles and squares) and lyrical abstraction (which is sometimes characterized as a form of expressionism).

In this book, you will find pieces of abstract art spanning the whole of the abstraction continuum. Alongside each piece of art is a description of the artist's work process, written by that artist. Artists discuss not only their artistic techniques and media, but also their inspirations.

You can use this book in a variety of ways, whether you're a beginner or an expert: for tips, inspiration, knowledge, or simply to look at and admire the talents and abstract artwork of many different artists.

Enjoy!

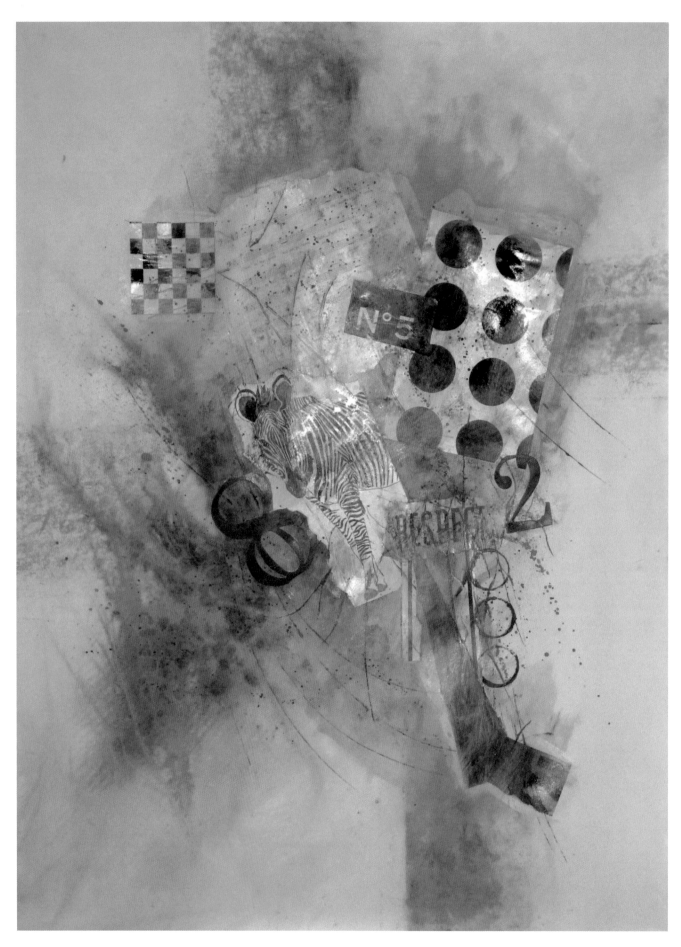

Black Circle by Sue St. John, AWS. Mixed media, 30"x 22"

THE PAINTINGS

Jacqueline Allison

What's fascinating to me about creating art is the intuitive mix of materials - application and life experience that result in a painting. I began this painting on gallery-wrapped canvas by drawing gestural marks in charcoal. Once I had marks over the entire canvas, I sprayed fixative to secure the marks to the surface. I generally start off working on a flat surface and then move to my easel when mixing different media.

My next step was to apply texture polymers to the canvas, allowing my intuition to guide where they were to be applied. I used a variety of textures but my current favorite is a crackle medium. It dries with a variety of spiderweb cracks; when applied thickly, the cracks are very deep. My next layer was to apply white gesso in random areas around the canvas and then utilize a palette knife to create marks through the gesso. These applications of texture are critical to my work as I love the rich surface it allows me to create. Again, I relied on my intuition and instincts to guide me on making the marks.

Once the gesso and polymer layers were dry, I used a large bottle of India ink and poured lines of ink in a grid pattern on the canvas. I poured lines of ink on one side and allowed it to completely dry overnight. Once dry, I then poured the other side. India ink is a very black and non-solvent ink. I love the deep color. This grid set a skeletal frame from which to build my painting.

Using black acrylic paint, I next added a layer of dark contrast to the canvas. Allowing my instincts to guide me, I applied the paint in various locations to create interest. Once dry, I applied a layer of unbleached titanium which has a warm tone – almost peach. Allowing each layer to dry gives me a chance to contemplate where the next color should be placed. After the unbleached titanium I applied a pale yellow acrylic paint mixed with white gesso. The bold contrast between the dark and light was very important to me in this painting. These layers were added for color and value balance on the canvas.

After applying these layers of color, I stood back to look at the painting and added more color as I felt was needed to give the painting strength. Once I had all the colors where I wanted, I took a dry brush with a little black paint and lightly scumbled over the surface of the texture to really bring out the marks.

Finally, I accentuated the lightest areas with white acrylic paint which emerged as the focal points. My painting was complete! My process involves many applications of layers and includes a lot of time to dry and also to look at my painting to get a sense of the next step to take. I love the rich texture and depth that this progression gives my paintings.

Creating abstract art allows the viewer to interpret a painting in a very unique and personal way. To me, creating art is a visual dialog that begins with the artist and continues in the viewer's own imagination.

Change is Gonna Come
By Jacqueline Allison
Acrylic & Mixed Media Painting
40 x 40"

Denise Athanas

I created this painting on 300# hot-pressed Arches paper. I began the underpainting by brushing in big, haphazard areas of color using Golden Fluid acrylics in light red sienna's and yellows; I had absolutely no subject matter in mind. In that first stage I am always able to improvise freely and be more creative. I am able to respond intuitively to lines, shapes and masses.

As the painting evolved the piece became almost like a jigsaw puzzle. I intertwined lines, values, colors, motifs and textures. I wanted to create a visual balance; in the process of working and reworking the surface many times an image began to emerge that evoked memories of Minoan urns.

At this stage I left the painting aside for a whole day. Then I went back to it, applied gloss medium in the middle of the painting, let it dry and then scumbled colors of red light, burnt sienna, ultramarine blue and diarylide yellow all over. At this point I wanted to create

texture. This was accomplished by pressing crushed tissue paper into wet pigment and removing it after it dried. Depth and transparency were achieved through a succession of multiple layers of color, both glazed and opaque.

I continued painting, contrasting values and defining forms. The small squares in the painting were created by taping a template of torn paper and spraying paint with a toothbrush. After it dried I added a few details and I continued building the composition by carving out large geometric shapes, moving dark acrylic paint by mixing Golden fluid phthalo blue (red shade), raw sienna and alizarin crimson hue to create a rich black. In the final stage, I added lines and curves to suggest an urn and texturized the section of squares made with a lot of spatter lines and color.

I knew I was finished but I put the painting away, not looking at it for a few days. When I was ready I just added some minor details and I knew that everything finally came together.

Minoan Urn by Denise Athanas
Acrylic on paper. 34 x 22"

As usual, I painted on 300 lb. hot press Arches paper. In this painting my approach changed as I used for my first coat a layer of Daniel Smith watercolors (new gamboge). I wanted to create a very loose surface and then work with my fluid acrylics. Of course, at this stage I did not yet know how much of the watercolor would show. I applied another loosely painted glaze of transparent Daniel Smith pyrrole orange and let it dry.

It was time for me to evaluate the painting and see where I was going. I decided it was time to use my fluid acrylics. I started painting my reds and yellows, adding and subtracting. This is the most fun stage for me. There is excitement in wondering where the painting is going to lead me.

I darkened areas of the painting with Golden fluid acrylic dioxazine purple with a touch of carbon black. I used diarylide yellow, pyrrole red and touches of green. I worked and reworked the surface until a design and a rhythm was established. I made marks and drew lines with a broad-tipped rubber shaper to reveal the lighter glazes below then let it dry.

At this time, I realized that the watercolor I used initially for my first coat did not show, but I did not mind because I had achieved what I wanted. I continued painting and refining forms and values. I added more lines to connect some shapes and lots of spatter and I knew I was finished.

Serenade
By Denise Athanas
Acrylic
22" x 30"

Lynne Baur

The Irish say they live in three realms: earth, sky and water, woven together by the light of the sun, moon and stars. Where these realms meet and mingle—a river bank, storm waves lifted into spray, sky reflected in water, hot wind on desert sand—there resides mystery and magic.

In watermedia, when colors meet and mingle under the action of the water, there also resides mystery and magic. I invite this magic into my work by using mostly water rather than a brush to move the color. Hot Sand is one of a series of paintings exploring the meeting places of earth, sea and sky, using the magical and mysterious meeting and mingling of color in watermedia.

I use rough paper to encourage granulation. These works have many soft edges and subtle transitions. Granulation creates variations in texture which add interest to the piece. I lay the paper on plexiglas and gently float water onto the surface, turning the sheet over repeatedly and floating on additional water until the paper is thoroughly saturated. I want to completely saturate the paper, but leave only a thin film of water on the surface. When the paper dries, the sizing settles back onto the surface, so I can still create crisp edges, dry brush work and fine lines.

Once the paper is saturated, I staple it to a support. Then I begin pouring strong color in swaths across the paper, tilting the support and coaxing the flow with a brush to encourage the colors to mingle and flow into land, water and cloud forms. As the colors begin to dry and move more slowly, I charge in water with a brush or small spray bottle or pour water or paint from a small cup to encourage additional flow in selected areas or to create wet-in-wet effects such as back-runs or stronger granulation, developing the emerging land/sky/waterscape through the action of moving water. The brush merely delivers or removes water or washes of color; I don't use it to push color around. By carefully observing the dampness of adjacent areas, I am able to encourage the development of landforms, cloud shapes or waveforms through the action of the moving water. The process can't be completely controlled—and that's a very good thing! If I enter into a dance with the water and the pigment, that's when the magic appears.

Once the paper is too dry to continue this initial wet-in-wet phase, I set the piece aside to dry completely. I carefully intensify color in some areas, mute it in other areas, enhance or soften edges, add small linear or organic shapes, always striving to merge these enhancements in a way that honors the magical gifts offered by the action of the water moving the paint. I try not to do too much. It's the water that makes the magic; my job is to invite the magic, and to showcase and celebrate it when it appears.

Hot Sand
By Lynne Baur
Mixed watermedia on Arches 140# rough
12" x 16"

Lisa B. Boardwine, BWS

This painting was created very intuitively with color, line and texture leading the way to the finished piece. The unpredictable quality of working in this manner is very exciting. The rich warm colors and undertones, with a touch of metallic zing at the finish, gave me the idea for the title of what the enticing drink in autumn would look like if captured in paint.

This painting was created on gallery wrap canvas. The building of an underlying texture is very important to me in my work so I first begin with a layer of white gesso on the canvas. I spread the gesso using plastic scrapers of various sizes in a random fashion. Other textural materials are sometimes added to the wet gesso to give the piece interesting marks and edges.

When this is dry, I begin with Golden Fluid Acrylic paint and start a layering process. I apply a dark pigment like Vandyke Brown Hue in some areas, and then begin to add rich warm color in an abstract design all over the canvas. I use different brushes as well as my fingers to push and pull the paint in the direction it needs to go. Some colors I enjoy using are Quina-cridone Nickel Azo Gold, Naphthol Red, Yellow Ochre, Nickel Azo Yellow, Titan Buff, Cobalt Teal and Magenta. I use spray bottles of both water and isopropyl alcohol to move the paint and add more texture. Lifting and tilting the painting allows the colors to blend over each other and this builds the layers of depth.

After letting the painting dry between layers, I continue to add warm tones in shapes, both geometric and organic, that are pleasing to me. Glazing over, scratching through, stamping into, and the addition and subtraction of marks allow the painting to have a life of its own. After several layers are applied I add heavy body acrylics in certain areas for impact. Highlights of a metallic gold are placed in strategic areas for a touch of interest. Dots and other symbols are pressed into the wet paint as well as painted on top of the last layer.

The canvas edges were painted black. When completely dry, I varnished the painting with Golden UV Satin to complete the look and protect the painting.

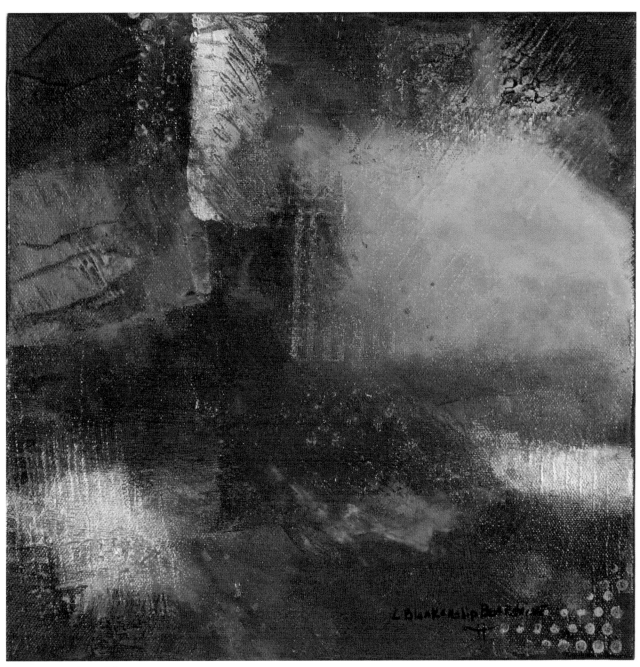

Hot Maple Toddy
By Lisa B. Boardwine, BWS
Acrylic
12" x 12"

This piece was painted on a 12″ x 16″ gallery wrap canvas. A textural layer of gesso was applied to the canvas with an old credit card and different plastic scrapers, some with jagged edges, to make lines and shapes for the beginning texture. Before the gesso was completely dry, I pressed different shapes and textured materials into the wet gesso to add more interest.

The first layer was intuitively painted adding the light areas first. With Golden Fluid Acrylics and Golden Heavy Body Acrylics, I layered in areas of Titan Buff and Aureolin Yellow in geometric shapes, keeping some edges soft and some sharp.

The hot, vivid reds came next. Blending, dripping and splashing Naphthol Red, Magenta and Quinacridone Crimson into the light areas gave the piece dimension. By adding Vandyke Brown Hue, Ultramarine and Violet Oxide next, the rich depth appeared. Touches of Jenkins Green and Cobalt Green were added for a cool balance to the warm reds.

As the layers progressed, I used various textural materials such as grid, lace, cardboard and stamps to press into the wet paint. From the patterns and shapes that emerged, I got a sense of mystery from the painting.

Certain sections were lightly glazed with iridescent gold. At this point I decided to add just a hint of realism. The key, which is a favorite symbol for me in my paintings, seemed to be a perfect fit for this piece, something that reveals and unlocks a mystery.

The edges were painted black. When dry the painting was varnished with Golden UV Satin varnish.

Secrets Revealed by Lisa B. Boardwine, BWS
Acrylic. 12" x 12"

Mickey Bond

This is a mixed media abstract painting featuring acrylic paint, acrylic mediums and torn tree-fiber paper from Thailand, Japan and Nepal. My process involves many layers and applications of acrylic paint, polymer mediums and other materials that resist paint, including rubber cement, plastic wrap and small rocks or stones. In addition, I layer free-form collage elements torn from mango, banana and mulberry tree-fiber paper. My first step is to swirl a stream of acid-free rubber cement (such as Best-Test Paper Cement) in looping arcs across a gessoed canvas or wood panel. In this case I used Joe Miller Signature Series artist canvas. As I pour the rubber cement, I bear in mind that these marks form the initial shapes of my composition. I vary the thickness of the rubber cement as I pour it to generate both fine lines and wider marks. After the rubber cement dries, I pour passages of blue, red and yellow Golden Fluid Acrylic paint in various dilutions with acrylic medium such as Golden GAC 100 in various concentrations. As I pour I tip the canvas at various angles, allowing the paint to pool and mix in some places but not others. I contrast pale washes of paint with denser color zones. Before the paint dries I press recycled plastic wrap into some of the paint as well as other objects that will leave impressions, shapes and marks. In this painting you can see the pebbly, irregular marks of gravel, rock and larger stones. Wherever I place these objects, I add more paint in a heavier medium such as polymer medium gloss so that a slightly raised edge will appear once the gravel and stones are removed. Further color mixing occurs as I pour off excess paint, both underneath the embedded plastic wrap and between the embedded rocks and stones.

I leave the canvas to dry until the paint beneath the plastic wrap and embedded objects is dry enough to hold the shapes that have been created. The paint is still tacky and often forms small pools under the larger stones. I may spill these pools or add more color and more objects to form shapes within shapes, or add paint if I find too much white canvas left. Eventually I remove all the plastic wrap, gravel, and larger stones. Now I let the painting dry completely. I then remove the rubber cement exposing a variety of white lines and shapes. Now I begin to add tree-fiber paper in a variety of colors and opacities. Each paper has its own character and fiber. In some papers tiny speckles of leaf matter can be seen, in others whole leaves or parts of pods appear, while the most translucent papers contain fibers like fine hair. I use a cheap foam brush and GAC 100 to apply layers of paper to my canvas. I like to tear the paper when it is both dry and wet to form irregular shapes that recall the spontaneous forms I've created in earlier stages of the painting by dripping, pooling, masking and embedding stones.

At this point I return to adding more paint in various ways including pouring, staining, and mark-making with a tube of paint. In this piece, I have enhanced certain passages with washes of zinc white and heavier marks of yellow ocher. I continue to layer paint and paper until the painting is done. Ideally, this is when paint and paper with all its layers, shapes, and marks form a composition that feels both spontaneous and inevitable.

Runes: Harvest Hues, 2. by Mickey Bon. Mixed media. 36" x 24"

Todd Breitling

This painting began with the selection of a paint brush. To me, this is always an intimate part of the process, as I prefer to use the same brush from start to finish. The type of brush I selected was a Loew-Cornell round white nylon brush.

Next, I decided to select the compatible colors of Cadmium Pale Yellow, Permanent Light Green and Ultramarine Blue. I added a Titanium White to infuse a different hue and to highlight the other colors.

The first color I used was blue, placing a long swooping line in the middle of the canvas. I followed that with a similar line of green near an outer edge of the canvas. This was followed by a yellow line on the opposite edge of the canvas. These lines were then enhanced numerous times to add luster and fullness to them. Soon, I had a "living" painting. I proceeded to add other symmetrical lines of blue, yellow and green until the canvas was nearly covered in paint.

The next step was to add some Titanium White to the lower central portion of the painting to give it some contrast. I also added some to the lower left portion of the piece to offset the white in the middle of the painting. At this point, the canvas was entirely covered and all I had to do to complete it was to go over all the lines I had previously painted to fill them in and touch up any overlaps. This was time-consuming yet fun because I knew I had just completed a painting I would be very proud of.

I let the painting dry for several weeks and then applied two coats of varnish to it.

Crazy Circles
By Todd Breitling
Oil on canvas
30" x 36"

This painting began with the selection of a canvas. I decided on a fairly large 24" x 30" artist canvas. The first step was to paint the entire canvas in Winsor & Newton Lamp Black Oil Paint. I used a Utrecht 4" painting knife to spread the paint on thickly. I let the paint dry for 10 days.

Next, I applied Utrecht Stand Oil, also using the painting knife to spread it evenly over the canvas. While the oil was still wet, the next step was to apply some titanium white in a broad arcing line from right to left. I used a serrated Utrecht painting knife to apply this line. Once this was sufficiently in place, I applied a parallel line of both orange and cerulean blue. These two colors blend well together and also seem to further highlight the white line.

I began expanding the white line by branching off of it using a painting knife to create a web-like look, which is at the left side of the piece. On the opposite side I added in more cerulean blue, while on top I added some acrylic cadmium yellow and cadmium red. I used the serrated painting knife to create "branches" or "trails". This was fun because it gave it the astronomy or galaxy look I was seeking.

After letting the paint dry for two weeks, I mixed an Envirotex solution which creates the epoxy resin that seals the painting and gives it the high gloss look. I spread the resin using a trowel and let that cure for approximately 48 hours.

Troop of Echoes
By Todd Breitling.
Oil on canvas.
24" x 30"

Martha Brouwer

I start a painting with an idea that I sketch out roughly in my sketchbook. Then I make a full-sized drawing of my idea on tracing paper.

I apply collage papers to Fabriano 140 lb. paper using matte medium. Fabriano seems to buckle less than Arches paper. I use collage papers that have some texture to them because that helps create the texture in the final piece. I tear the various papers and apply them so that there is a variety to the texture.

I look at my drawing and choose where I would like large light and dark passages and choose what color palette would look good with my vision of where I want to go. After those decisions are made, I wash in the large lights and darks with a brush and let that dry.

Now I go in with a palette knife and paint similar hues and values to the wash underneath. In this way the whole paper is covered with color before I begin to pull out the image.

I transfer the tracing paper image onto the painting using white or blue transfer paper depending on how dark the ground is. Finally, I start painting using my drawing as a guide. I keep fairly close to the background colors but go darker or lighter in value to bring out the image. I want it to look like the image has been pulled out of the background.

Then I pop some pure colors out in key places. I try to let the original vision for the painting guide me in terms of the feel of the piece.

I don't usually experiment wildly as I paint. I take a lot of risks in terms of what I attempt to pull off and it often doesn't work. I do try to stick to my dream of how I want it to look. It usually takes me 3 to 5 days to complete a painting and half of those I paint over – at least the texture is still there.

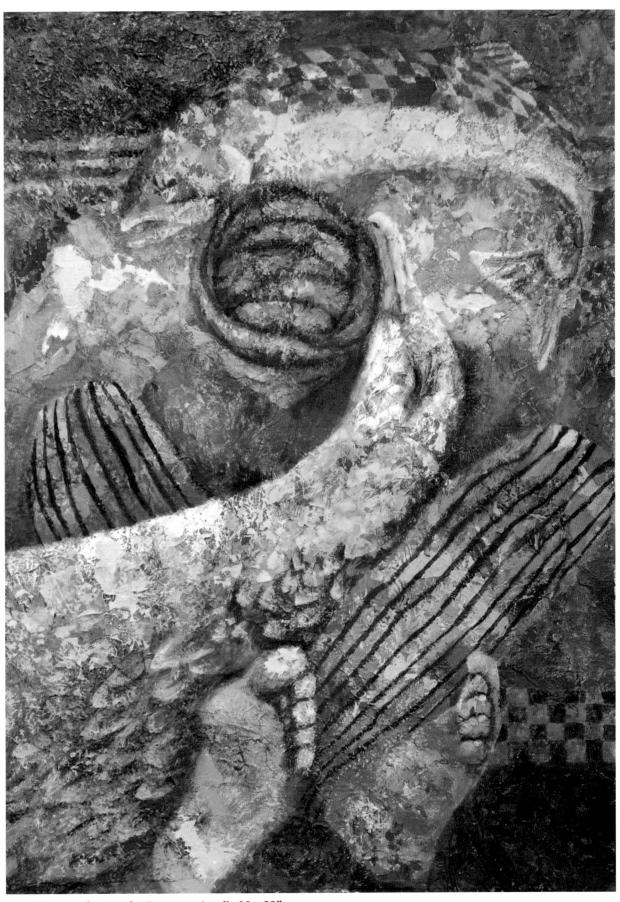

Harmony by Martha Brouwer. Acrylic.30 x 22"

I start a painting with an idea that I sketch out roughly in my sketchbook. Then I make a full size drawing on tracing paper.

I apply collage papers to Fabriano 140 lb. paper using matte medium. Fabriano seems to buckle less than Arches. I use collage papers that have some texture to them because that helps create the texture in the final piece. I tear the various papers and apply them so that the texture is not uniform throughout.

I look at my drawing and choose where I would like large light and dark passages and choose what color palette would look good with my vision of where I want to go. After those decisions are made, I wash in the large lights and darks with a brush and let that dry.

Now I go in with a palette knife and paint similar hues and values to the wash underneath. In this way the whole paper is covered with color before I begin to pull out the image.

I transfer the tracing paper image onto the painting using white or blue transfer paper depending on how dark the ground is. Finally, I start painting using my drawing as a guide. I keep fairly close to the background colors but go darker or lighter in value to bring out the image. I want it to look like the image has been pulled out of the background.

Then I pop some pure colors out in key places. I try to let the original vision for the painting guide me in terms of the feel of the piece.

I'm not a painter who experiments wildly as I paint. I take a lot of risks in terms of what I attempt to pull off and it often doesn't work. I do try to stick to my dream of how I want it to look. It usually takes me 3 to 5 days to complete a painting and half of those I paint over – at least the texture is still there.

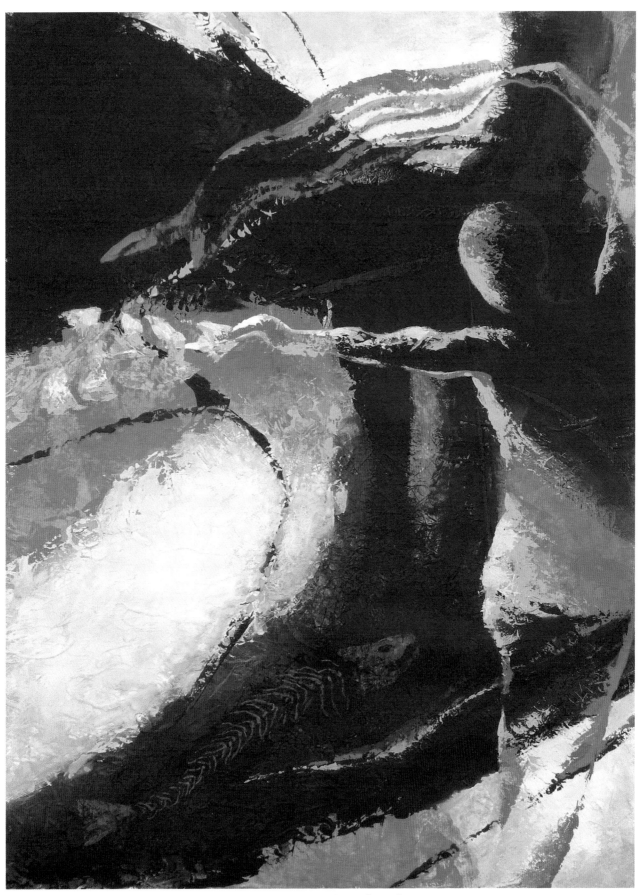

Without Death There Is No Life by Martha Brouwer. Acrylic. 30" x 22"

Carol Carter

First, I lay down a pencil outline of the image to be painted. Using a resist, I paint mostly the leaves and twigs protruding from the water as well as ripples and reflections. I wet the entire paper with clear water from a spray bottle.

Next, I float in pure color such as antwerp blue from the bottom and sides of the paper, leaving the center mostly white. I allow this to dry and puddle, controlling the blossoms to stay in the center of the paper. Then, I float in the secondary wash of shadow violet and moonglow to add depth to the water. I allow this to totally dry and remove the resist masking. I then paint in the leaves and twigs using a combination of shadow gray, quinacridone burnt orange, and aureolin.

The last stage involves painting in various ripples using the colors from the water.

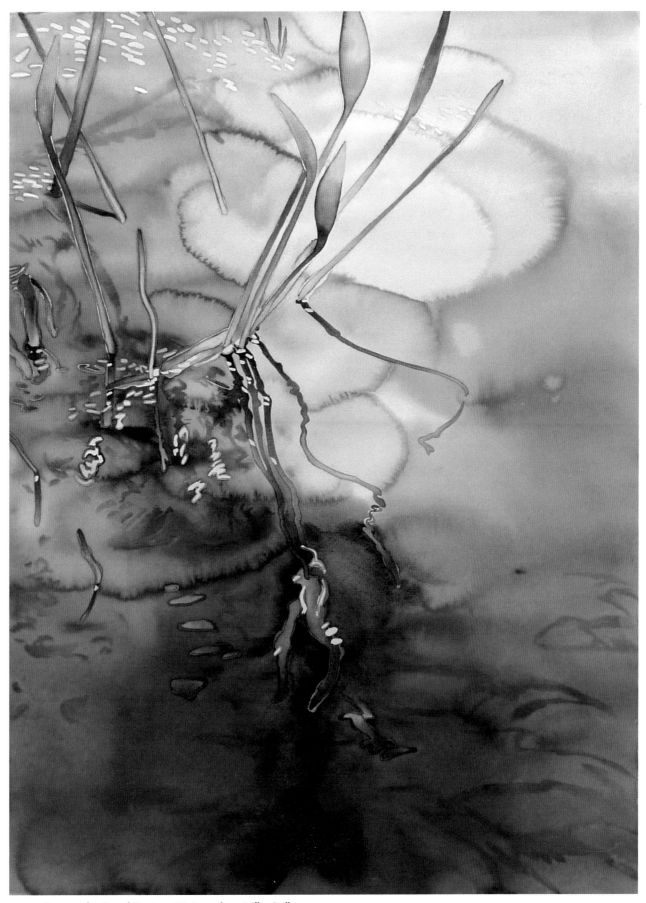

Swamp by Carol Carter. Watercolor. 46" x 34"

Katy Cauker

This piece is a monotype done with rubber-based printers ink on BFK paper. I used a 1/4 inch sheet of plexiglass for the plate. I use a grinder to bevel the edges of the plate so they are soft enough to not cut the paper but still give a nice plate mark. I buy cans of ink from the print shop supplier. They have a wide range of hues but I use a basic primary color set plus white and then mix all other colors from those. I mixed these with Miracle Gel to thin the inks to a pliable consistency. I then add Stand Oil to some of the hues to give me an oily ink.

I apply inks with rollers and brushes then draw back into it with the end of the brush, a piece of mat board or a Q-Tip. Where ink is removed there will be white marks where the paper shows through as in the calligraphic marks in the upper left. To soften that contrast I roll back over the drawn areas to tint them so they are not the same white of the paper. In some places I rolled oil-based ink down first then a non-oily ink over the top which establishes an oil resist pattern that adds texture with a dappled effect, giving the print another dimension.

I generally do not start with a firm idea but prefer to work with what comes to mind as I apply ink to the plate. I started this one with the firm drawn line of black ink. I rolled the light tones in first, I added oil to some of these, so when I rolled the dark non-oily ink on top I got the broken pattern I was looking for. This can be seen in the black area of the lower left and the dark blue area in the center, as well as the mid tone blue green area where there is less contrast but good texture. Much of the patchwork areas are done with the roller allowing it to pick up ink off the plate and transfer it to other areas to create gradations. I also draw with the edge of the roller, which leaves a spongy type of mark that is part reductive and part additive, as the roller used this way will leave and remove ink.

The brush work in this piece is most evident across the bottom and the right side. There are several layers. I did brush work early, on a clean plate, then rolled over it and did more brush work. I also worked back into the print after running it through the press to create the layer that is most out front. The hot pink in the upper center area is brush work done on a clean plate with a heavy amount of ink, so that it sits up and is not muted by the layers added on top, which show as underneath once it is printed.

I worked the imagery by setting up a diagonal dialogue with the shapes and alternating light and dark. I used the softened yet hard edge contrast between the white and blue to place visual stops, while I used the black lines and hard edge thrust against the blue to create dynamic movement along the vertical axis. The brush work across the bottom and on the left enhance this flow with the feathery calligraphic lines suggesting wind and atmospheric energy.

The ink is very transparent so it develops layers that quietly add depth. I gave the piece weight with the small but important addition of the black in the lower left, broken dark along the bottom and through the middle. I find this type of ink yields a piece that has the tactile lush quality of an oil painting and the transparent spontaneity of watercolor. The BFK paper has a thick, almost cloth-like feel to it providing a rich surface as a base.

The titles come at different times but usually as I look at the finished piece, as this one did. I often write extended titles or short poems along with my work. I always choose a title based on something about the piece so that when I read the title I have a visual image of which piece it is. I had recently completed a series of paintings based on aerial views from airplane windows. I found this piece to be reminiscent of those works, and views I hold in my head from vacation flights.

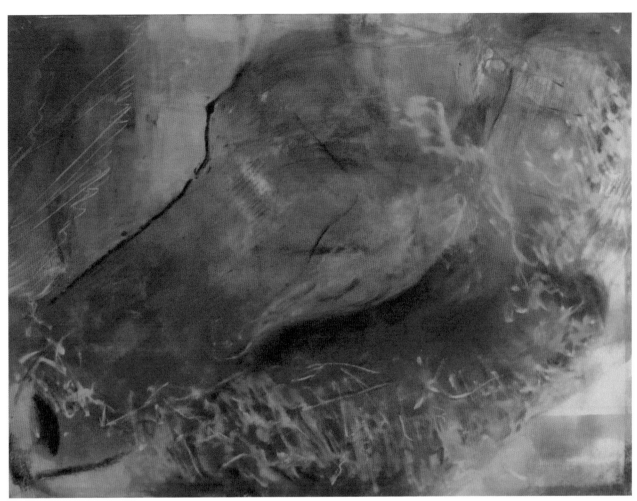

Island Shoals
By Katy Cauker
Monotype/mixed media
22 x 30"

This small acrylic was done while traveling to visit my mom. She has Alzhiemer's disease

or some similar variant of age-related dementia. I love to visit but find painting the Texas

landscape uninviting after the drama and beauty of the Oregon coast. I have gradually set up a mini-studio that lives in my mom's extra closet, so that I can work while I am there. For this piece I bought a basic palette of Ultrecht acrylics and a Fredrix professional grade birch panel covered in canvas.

I had no image in mind but was searching for a way to relieve the stress, and entertain and engage my mom. She has great difficulty in "doing" now, which is frustrating for her as a once very active and capable person. She loves to watch me paint and will do a little of her own work along the way.

I began by selecting a medium-sized brush that seemed just on the large size for the size of the panel. I chose a synthetic bristle with good flexibility. I started work in the upper left, an arbitrary decision based solely on the feeling of the moment.

I began mixing greens because I didn't know these paints. I wanted to know if the blue and yellow I had picked up would mix into a decent green; my past experience tells me that is not always the case. I liked the texture and bright white of the panel so I mixed in matte medium to thin the paint, and began with the idea of developing transparent or translucent layers.

Sometimes when I am doing a monotype I start this way, just looking at the color and the stroke marks until a sense of patterning surfaces. I try to lose myself in the feeling of the paint under the brush and the visual stimulation of color and fluidity.

An artist I like to work with, Erik Sandgren, talked one day about making all the corners different as a way to jog yourself when you have reached an impasse, particularly while working on location. So I worked out a ways from the corner then shifted color but continued the brush stroke I had found pleasing. In this way I began to work across the panel. I generally work all over, laying out a plan that includes all parts of the format from the beginning. Because I had no plan I worked diagonally feeling that would be more energized and less likely to stagnate than had I proceeded straight across in quadrants.

I have always liked to have motion in my work. The fluidity of the stroke developed a natural wave motion. I paint on location at the Oregon coast every year and often choose the water as my focus. Also, I had recently been to Hawaii and as an avid swimmer I was consumed with the pleasure of immersion in the aqua-hued warm liquid of the Pacific at Waikiki Beach.

I allowed the painting to continue to have cohesion around the brushstroke but developed diversity with contrast, and working on gradations within each area. Erik's dad, Nelson Sandgren, (my first teacher for painting on location) did dynamic pieces that utilized white forms often developed by leaving negative space in watercolor. I wanted a dynamic white shape for this piece that would become the focal point and set up a dialogue with subtler tones in a loosely developed background.

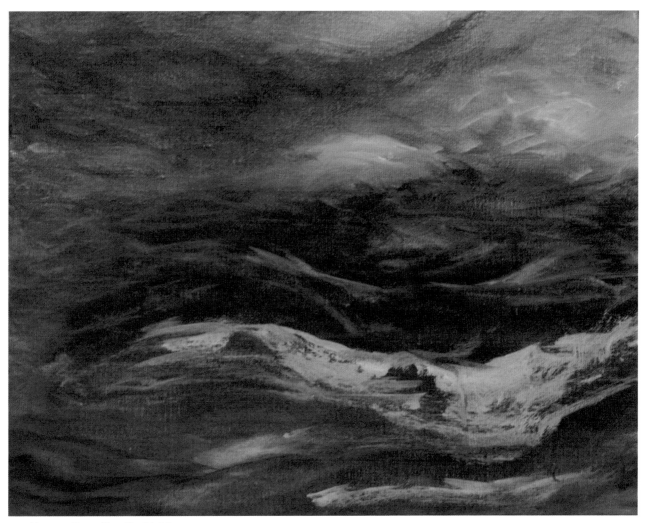

Texas - Traveling the Void
By Katy Cauker
Acrylic on canvas-covered panel
11 x 14 x 1/4 inch

Elizabeth Chapman

I began this painting on a 30" x 40" x 1.5" Edge gallery wrap canvas with an undercoating of Holbein's yellow ochre gesso. As the paint would be applied purely with a palette knife, I knew that there could be the possibility of parts of the canvas peeking through. I did not want the white to show through and felt that the yellow ochre would neutralize this effect.

The first choices that I make are often the most difficult. As I work intuitively this will determine the direction that the work will take. I chose to begin on the left side of the canvas using my palette knife and blue colors. When working with a palette knife painting, the paint is directly applied to the knife from the tube or jar. The mixing of the colors occurs on the canvas itself, and with the left side it was done with a vertical and horizontal movement. Colors used: Golden Heavy Body Acrylics: Light Green, Ultramarine Blue, Cerulean Blue and Cobalt Teal; Liquitex Heavy Body Acrylics: Bright Aqua Green, Vivid Lime Green, Light Green Permanent and Chromium Oxide Green. All of these were mixed with Golden Cadmium Yellow Medium creating more varieties in greens.

Later, I worked with the warm colors on the right side being careful that they didn't become too strong and overpowering. It was also at this point that I used tidbits of the warms in the blue side to create unity. Warm colors that I used were Golden Cadmium Yellow, Cadmium Red Dark, Cadmium Orange, Pyrrole Red and touches of medium magenta.

Lastly, I changed my direction and technique in the upper right corner. Still using my palette knife I loaded it with Golden Nickel Azo and Liquitex Iridescent Rich Gold. Using a circular motion with lots of arm movement, I created the feeling of warmth from the sun as a new day begins. As I mentioned I work intuitively, so much of the time I continue to work believing that it will come together at some point. It was at this step after adding the metallics that I saw it, thus the title "New Dawn".

The finishing touches are what I call the jewels. These can sometimes be the smallest and most subtle details, but can also make the biggest impact on the final painting. In this painting, I added small squares of color in the blue to differentiate an area and have a variety of sizes. I normally paint my sides but with this painting I left the sides the original yellow ochre of the underpainting. The painting was then finished off with a Liquitex Gloss Varnish for added protection from sun and dust, and wired on the back. Ready to hang!!

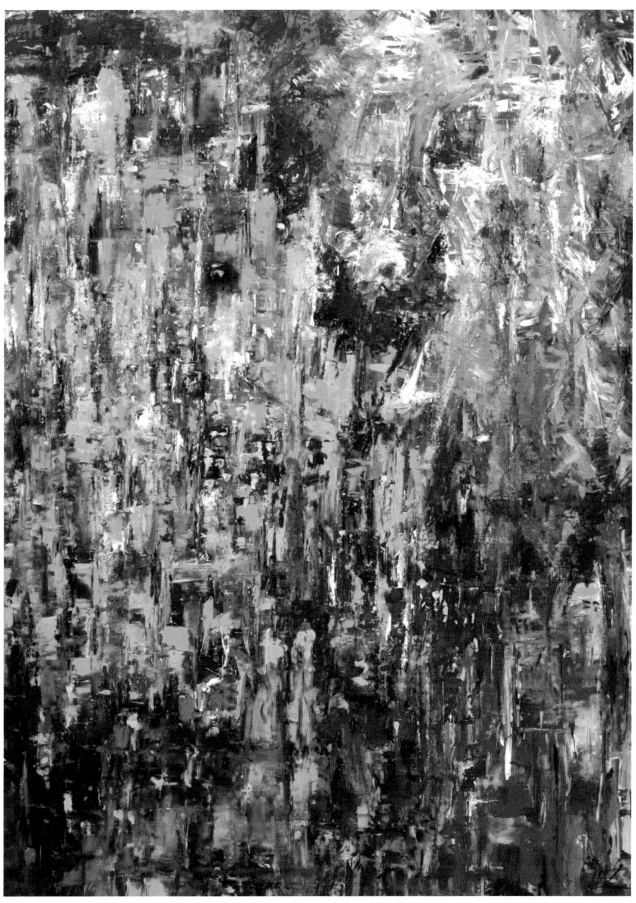

New Dawn by Elizabeth Chapman. Acrylic. 30" x 40" x 1.5"

Elizabeth Chapman

This painting was begun on a 36" x 36" x 1.5" Edge gallery wrap canvas and uses a variety of techniques. First the canvas was textured by applying Golden gel medium with a palette knife. As these textures were being applied I thought about how the canvas was to be broken up. As I work intuitively, the only choice I made as I began this painting was that it would be a mostly red painting.

When this was dry, I used a large #14 brush to mix the various reds (Golden Cadmium Red Dark, Pyrrole Red) mixed with Cadmium Yellow, Burnt Sienna and Burn Umber. With this technique the paint is applied to the canvas with the brush using a circular motion to blend and soften the colors together. The canvas was layered and covered with the dark colors and reds.

As I began to see a composition emerge, I switched over to using a roller to add the rectangular shapes. The roller was applied softly to indicate various sizes of contrast with cooler colors of Golden Cobalt Teal, Light Green and Magenta. Smaller brushes were also used to further emphasize smaller rectangular and square shapes.

I decided to add the horizontal band of black creating a high horizontal composition. This created unity and balance--yet I still felt it was too much and there was something lacking. I pondered over this for many days before an idea came.

The solution seemed to be a value issue. The painting needed to have some lighter values added to it and so I added the lighter white on the left. To balance this area out I carefully added various mixtures of white (Golden Titanium White mixed with a bit of some of the other colors I had used) and lightly applied them in a feathering type of motion to the upper right. At this point I continue to pull these whites down over the horizontal line breaking it up so that it wasn't quite so obvious.

Lastly, I used the side of my palette knife and fine skinny brushes to draw circular and straight lines using a bit more black to balance the center band. I look for these in the painting and simply help to draw them out. With the finishing touches down, the painting is then ready to be sealed with two coats of a Liquitex Gloss Varnish for added protection from the sun and dust. The sides were painted black and it was wired on the back

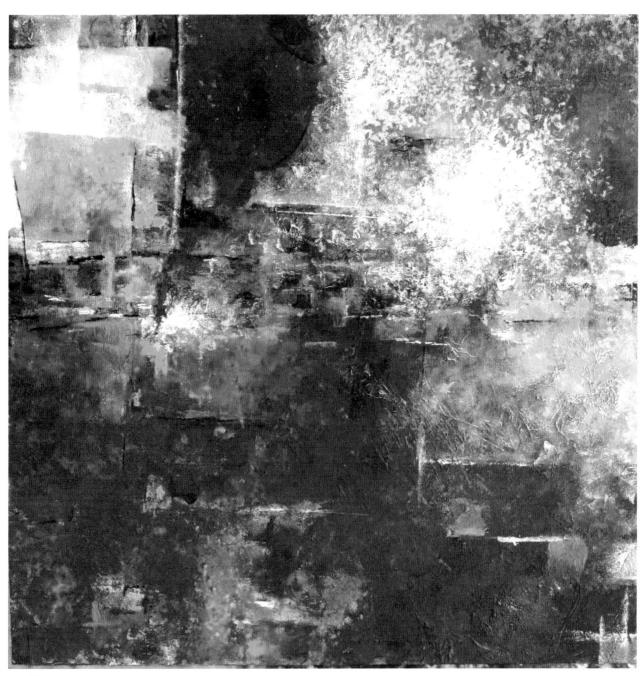

Traverse
By Elizabeth Chapman
Acrylic
36" x 36" x 1.5"

Susanne Darius

I prepared my canvas with two coats of acrylic gesso. In this particular painting, I applied the first coat with a large angled house brush, letting it dry between coats. The second coat of gesso was applied with a large palette knife to give it texture and allow the paint to cling to it differently as it moves over the canvas. These two coats of gesso allow the light to penetrate the successive layers of paint and bounce off the white gesso, giving my paintings a luminous quality.

I then applied one thin coat of quinacridone gold acrylic paint to the gessoed surface, working quickly to cover the canvas. This needed to dry thoroughly before I continued. I paint with a collection of heavy body paints and fluid acrylics.

I then assembled all my reds: orange red, quinacridone violet, crimson and burnt orange, and covered the surface of the canvas with different shades, allowing the edges of one color to overlap with the other colors, then dry brushing the paint over each other with lots of variation. I kept the reds darker in the corners and lighter in the center. I kept applying the paint until it got sticky. There seems to be a point when there is enough paint on the surface of the painting when the paint can adhere to itself and create interesting effects. I worked at it until the surface looked like red leather.

After this dried I decided to divide the canvas into compartments (like the name). I made a rectangle in the upper right corner and dry brushed an off-white border around it. I mixed some of this green paint with some orange and made a square, almost the same size as the one in the corner on the bottom middle edge.

Next, I laid the painting on the floor on a drop cloth and put some fluid paint into disposable plastic baker's pastry bags with tiny holes in the end. I squeezed off-white paint out of this bag in several lines and squiggles. I flicked a fully loaded large paint brush with green paint and made two lines vertically down the right side. Black was also squeezed from another pastry bag. Using lots of arm gestures with the pastry bag gives a fluid, fanciful movement to the painting. The finishing touch was some bronze metallic paint here and there to catch the light.

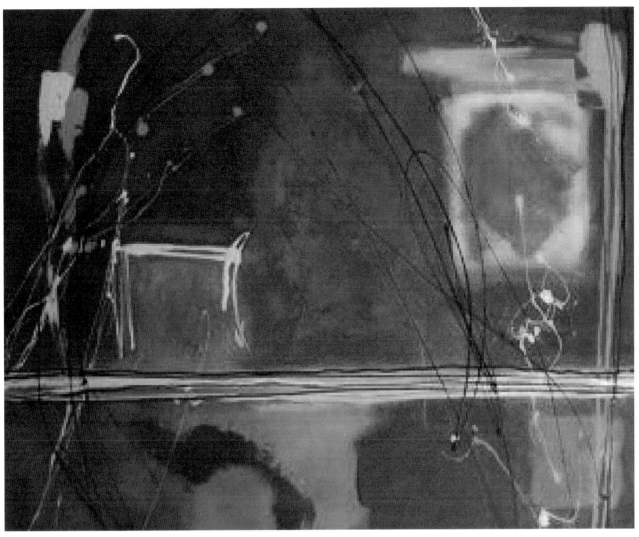

Compartments of the Mind
By Susanne Darius
Acrylic
24" x 30"

Jan Hunt Dawson

This abstract started with a simple cruciform framework. The geometric designs were placed one on top of the other until the end result was accomplished with colorful chaos.

The shadows were added to the geometric designs to give depth and to let the viewers look down into the gridlock of designs.

The watercolor paper is 300 lb. Arches because it can stand up to many layers of paint, taping and scraping.

Oil pastels were added at the end to carry the energy throughout this piece.

Above Gridlock
By Jan Hunt Dawson
Watercolor / Oil Pastels

This abstract watercolor evolved through the process of painting angular shapes, one upon another, in a cruciform. The choice of color reflects the power of red, interspersed with white as a break from the red. The black background sets off the contrast between the red and the whites and grays.

The watercolor paper is 300 lb. Arches because it can stand up to many layers of paint, taping and scraping.

Oil pastels were added at the end to carry the energy throughout this piece.

Red
By Jan Hunt Dawson
Watercolor / Oil Pastels

Sue Donaldson

This painting is about movement and the interplay of intense colors. I used nature as a starting point: the impact of the BP oil spill on life in and along the Gulf of Mexico. We were all appalled by the explosion and what it brought: havoc for the environment and man. Devastation, disappointment and death were everywhere!

On a cradled wood-panel, 16"x 20"x 2" surface, I "slapped" on white gesso creating texture as I went. I loosely drew lines with watercolor pencils to depict the flow of water and the shoreline from a bird's-eye point of view. I used watercolor pencils knowing that the lines would melt into the acrylic colors. I considered color, movement and energy. Energy is everywhere flowing within us and around us. Color, line and form are more important to me than the details of the subject. Dark rich angry colors of invading death are depicted. They swirl near the greens and yellow expressed as life desperately fighting to survive. The blues/turquoise suggest life maintaining itself. Dots, lines, swirls and circles complete the picture. When I create, I express what I feel rather than illustrate what is seen.

The colors I used include: Golden colors: Quinacridone Burnt Orange, Diarylide Yellow, White Gesso, Holbein Acryla colors: Compose Blue 2, Violet, Katsura Blue, and Nova colors: Phthalo turquoise and Yellow Green. The colors blend and flow together to create both hard and soft edges. After painting the edges of the cradled wood sides with black acrylic paint, I varnished the painting with a protective covering.

I enjoyed the process of this painting. It is one of my ways to connect with others on an emotional level. While I am painting, I am deep in the process of creating a thought, a dream, or an idea. By using the surface of wood and holding a brush flowing with paint, I can express and share my thoughts with you.

I had a dream recently about a piece of art being destroyed by flooding but then it was saved, restored, revived and now relives. It occurs over and over and is saved again and again. I can relate that to our Gulf Coast and man's mistakes and missteps. The waters and shoreline of this area are being brought back with hard work and nature's magic.

Gulf Stream
By Sue Donaldson
Acrylic
16"x 20"x 2"

Joan Dorrill

This is such a small painting that I thought it would go quickly and it did, for the most part. I started with a 10 x 8" flat canvas panel. These are actually easier to work with if you plan to do any printing of images with your handmade or purchased stamps. Stamping is a bit more difficult to control using acrylic paint than ink, but it is permanent. With a bit of practice it can be handled with satisfaction. The paint needs to be somewhat thick and it is best to roll it on with a sponge paint roller or hard inking roller.

First I started to apply painted beige rectangular shapes using a flat synthetic brush. I started at the edges and painted in from there. While this was drying I tore some shapes from my aged music papers to add to the edges of the beige shapes. These are glued with matte medium which will dry clear. If you like to make paintings with an old look take any newsprint, music, or other pictures in black and white, thin out some raw umber acrylic paint, and brush this over it somewhat evenly with a flat brush. Let this dry and you will have your old weathered papers to use in a collage. It is just that simple.

In the same way I then glued some pre-painted tissue paper pieces that were painted in red and purple, leaving some white areas for light to travel through the piece. You must spread out the tissue paper and paint it with acrylic paint, then let it dry on a piece of plastic such as a garbage bag. Printing with paint using bubble wrap for a pattern gave some added texture and yellow color which contrasts with the purple and makes it look even purpler. Just for fun I used some small bottles of paint with pointed ends that you can write and draw with and drew the heart lines. These lines are thicker than brushed-on paint so let those dry 30 minutes or more before proceeding.

I looked and tried to decide how to add interest. Voila, my rubber dragonfly stamp did the trick using light and dark paint colors. I printed the dragonflies in darks and lights which puts a bit of action into the design with about the right amount of delicacy to look lacy. I did not want it to look too much like a Valentine. I then look for something to give a punch and focal point. There was a piece of metallic plastic lying on the pile of collage papers. The plastic came off the rim of a wine bottle and is a dark red that looked good with my other reds and purples. I held it to a hot light bulb and watched it pucker and curl into a 3 D shape, perfect for the focal point. This I glued down with heavy acrylic medium. When it was dry, I painted a touch of gold paint on the top of it and glued down another small piece of aged music. The finishing touch was to fill in some of the tiny circles with red.

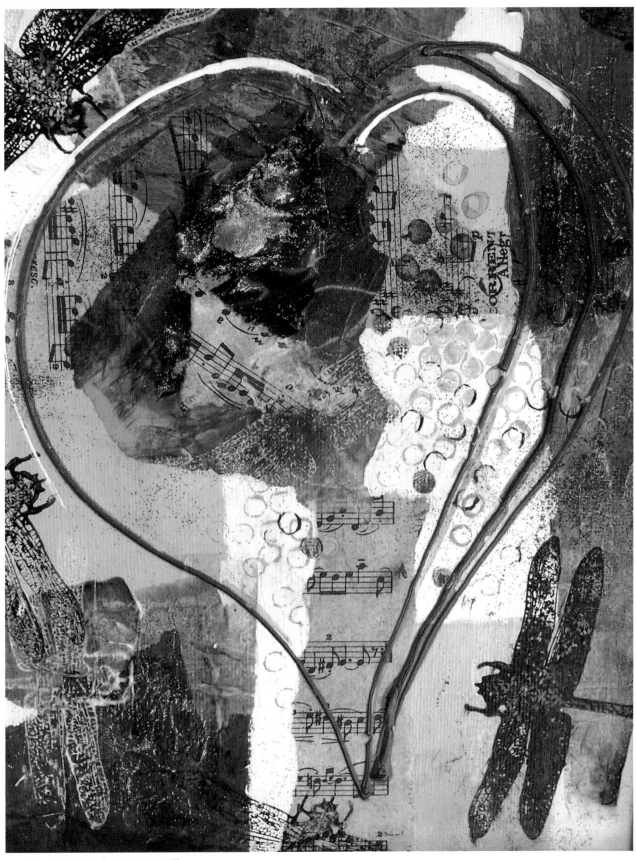

Singing Heart by Joan Dorrill
Acrylic/Collage. 10 x 8"

Starting this process was great fun and a big challenge. This is a recycled canvas given to me by a friend, Carolyn Kelso, who did not want it anymore. She now lives in a condo with space being a real problem. So, Voila! A 60 x 48" canvas was now mine to do with as I pleased. It had been custom-made for a particular exhibition that had completed its rounds. The thing was sitting in my garage wrapped in a huge plastic drop cloth, so the first thing was to remove the plastic. It was a huge collage type piece of work so I first removed the largest pieces of attached shapes and pulled off the collaged paper and cloth shapes. I realized at some point that there were some handmade primitive-looking beads sewn to the piece so I left some of those in place and removed others.

There was a lot of looking and thinking about a new composition before I began to apply acrylic paint over the canvas. My process is to work intuitively from the first paint mark. First I felt the need to obliterate the original composition and to neutralize the colors by applying shades of beige and gray paint to the canvas. I did this using a wide flat synthetic brush, all the while leaving some of the original colors peeking out through the overlays. Now I could decide where to place more light shapes and dark shapes in order to establish a new composition.

There were already many small circles showing through from the old design so I decided to place a large circle as the center of interest in a light color, almost white. I also added some patterns of smaller circles in different colors and sizes for variety. The whole design began to take on a mood of moon light; and with the primitive beads peaking out here and there I could envision bits of flora and fauna, and sounds in the night, maybe in a deep jungle.

I made some new print-making plates with primitive looking symbols. These were then inked with acrylic paint and used to print onto areas for texture and variety. Some of these reminded me of hand-printed fabric worn by villagers in remote places.

For the finishing touches some of the beads needed to be different colors so that was solved with a bit of acrylic paint and a small paint brush. All of the edges were painted during the whole process so that the image would blend around the corners of the deep wrapped canvas. Thus was born Voodoo Rhythm.

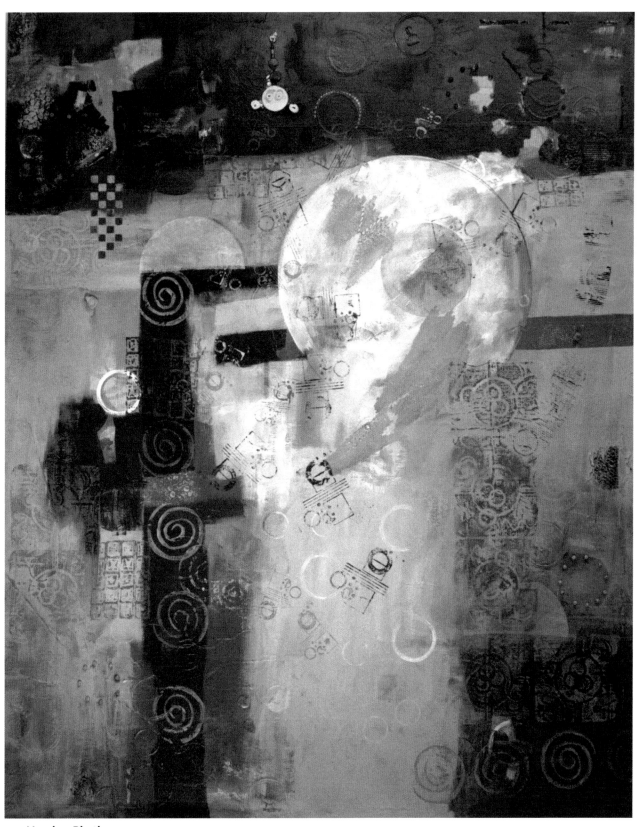

Voodoo Rhythm
By Joan Dorrill
Acrylic with handmade beads
60 x 48 x 2"

Autry Dye

The inspiration for my painting comes from an unusual source. The trigger for this painting was from a plant that I have. The plant grows in water; various rocks and pebbles stabilize it. While looking at it one day I thought about the earth, how the big rocks were deep under the crust and the smaller rocks and pebbles came to the top. I wanted to try and get this effect.

I selected some Crescent illustration board. I wanted a smooth surface, but a ridged support, thinking I would do some pouring of the paint and let it run. When I work experimentally I am always open to what is happening on my work surface. I change my method as I see interesting things happening.

When using illustration board, I first put a coat of wax on the edges of the board by simply rubbing canning wax down the sides. This wax prevents liquids from seeping between the layers of the board and separating.

Working flat, I placed florist river pebbles above the center of the board in a design that I wanted. Using very liquid watercolor I poured this mixture around the pebbles. I used watercolor at this stage of the painting. If I had used acrylic paint it would have acted as glue and my pebbles would have been attached to the surface after it was dry. I used a heat gun to push the paint and dry the area quickly so I could see the results.

I am an impatient artist so I want to caution anyone who wants to use a heat gun to be very careful. You can get too close to the surface and damage it. You can get this same effect by letting it dry overnight or by using a hair dryer.

After this area was dry, I sprayed it with a workable fixative so it would not be disturbed when I did some reworking around the area.

The large bottom area was rather straightforward. Using a large brush loaded with unbleached titanium acrylic I painted this area and let it dry. Working quickly, I used a glaze of yellow ochre over this area. While the surface was still wet, I placed plastic wrap with wrinkles on the surface to break up the large area. I wanted to have the effect of vague rock shapes. I checked the plastic wrap after several minutes to make sure the lines from the wrinkled plastic had formed. I wanted them to represent fissures in the rocky lower strata. You must not let it dry completely or it will attach itself to the work. As the lines stabilized I removed the plastic wrap. I then painted some of the shapes in white. Letting this dry, I rubbed yellow ochre glaze over the surface to subdue it. I did not want the area to dominate the rest of the painting.

Using unbleached titanium I covered the sky area. Using the heat gun, I pushed the paint out to create a circular sun. For design purposes, five suns worked well.

Tweaking the almost finished piece is the best part. I added dark green to represent water pockets among the rocks and some pure white areas as an accent to my line of top soil. To finish up the work I splattered some burnt sienna acrylic in areas on the bottom of the work while protecting other areas of the painting to pull it all together.

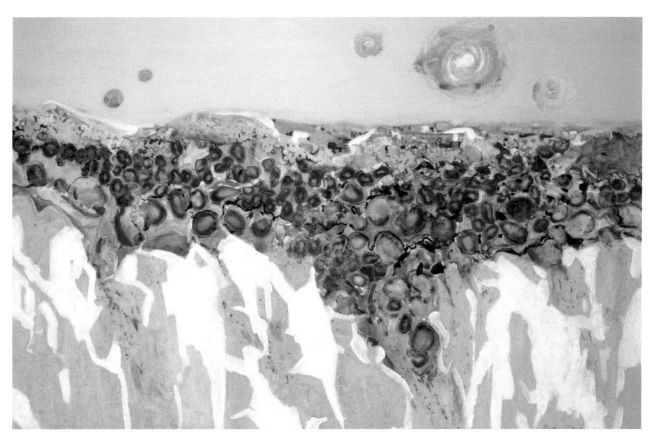

Earth Series
By Autry Dye
Watercolor and acrylic
20" x 30"

Kristi Galindo Dyson

This painting is the product of recycled work. I began this piece by starting with an unresolved earlier painting that was done on multimedia artboard. I also had some unsuccessful watercolor paintings that I had torn up to use in collage work. I began by randomly placing pieces of the watercolors on the surface of the artboard. As I discovered interesting visual relationships developing I glued the pieces in place using acrylic matte medium. I began to establish some order by using the collaged pieces to create a framework to build a new painting on. I liked the crisp darks that were in some of the collaged pieces so I looked for ways to add more contrasts with added darks. I was careful to not let my darks become too spotty or disruptive. I used them to create direction in the movement and to serve an anchor on the top and at the bottom.

Because I was using old work I had a lot of busyness that was competing with what was beginning to come together in the new composition. A variety of greens became my dominant color as I began to build unity by covering the competing areas. Some crisp yellows that were in the collaged pieces became very important as I established some light values to complement the dark areas. I also worked in some cool neutrals to offset the warmer yellows. Because I started on a surface that was already covered with paint I had the option to let surprise colors peek through the new work. The unexpected color bits create a liveliness in the more dominant color fields . Since the painting is predominantly cool, the small areas of warm color become very important in creating an exciting visual tension in the work.

My painting approach is very intuitive as I work through a process of adding and subtracting visual elements.. I work best when I work quickly as it keeps me from over- thinking my work. In all of painting and most especially in abstract painting, I believe it is important to let the work itself direct you. I learn to recognize what is happening as I paint and respond to it. I trust my instincts and strive to make bold, confident strokes. If I come to a place where I am unsure of what to do next, I stop and evaluate. My painting may be done or in time it may reveal a new direction. I have overworked many a good start but I have found that to be part of the process of creating. To keep my work fresh and exciting I am willing to take the risk of ruining it. However, nothing is wasted as old work may always become the starting point for new work. and be the means to a whole new approach.

This painting was coated with a mixture of matte and gloss acrylic varnishes to protect and to create a unified finish on the painted surface.

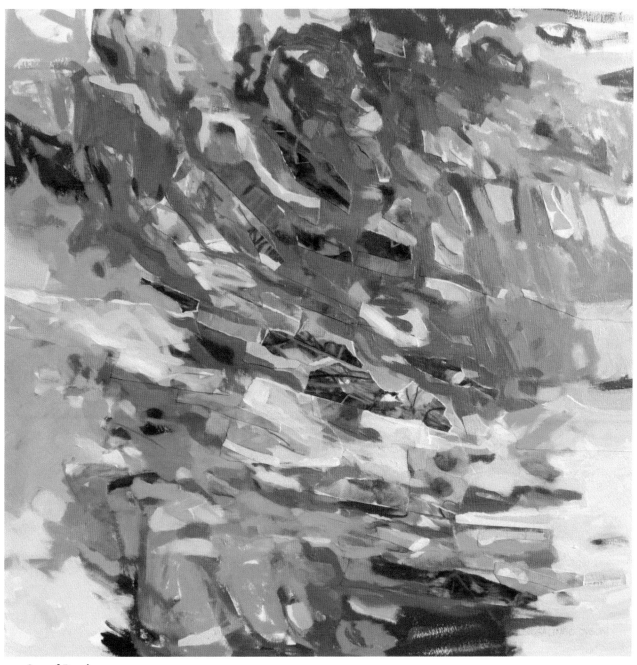

Sea of Reeds
By Kristi Galindo Dyson
Mixed water media with collage
30 x 30"

I began this piece by preparing some papers to collage onto the painting. Using watercolors with watercolor pencils, watercolor crayons and some graphite, I made random marks on my papers. I prefer 80 lb. Strathmore Aquarius paper because it handles all water media and its lighter weight makes it easier to collage. Various printmaking and drawing papers also work well if they have a soft tooth. Occasionally I will use rice papers for their textures. I both tear the paper and cut it with a Xacto knife to have pieces of various sizes with a variety of edges to work with.

My painting format is a 30 inch square of white multimedia art board. This surface has a light tooth and can accept most mediums. It can be prepared with a gesso or worked on directly. I painted directly on the surface using acrylic. I began by using a mixture of warm colors such as burnt sienna, pyrrole red, yellow oxide and hansa yellow. I made random marks with these colors to cover a large area of the painting surface so that I would have plenty of warm color to peak through the layers that would come next. I then added some dark marks using graphite gray and paynes gray. Mixing these colors with hansa yellow and white gave me some warm and cool neutrals. I worked back and forth for awhile looking for interesting transitions between the color fields that were developing. When things get too busy I come in with white or a light neutral to cover up some of the areas that are getting overworked.

During the painting process I lay down pieces of my painted papers, moving them around the painted surface until I find interesting visual relationships. Once I've decided on their placement I collage them to the surface using a matte acrylic medium.

I evaluate the piece by viewing it from different angles. Since I work primarily on squares I continually turn the piece while I am working to better understand what is developing. In this piece I added more paint after I collaged to incorporate the collaged elements into the piece. I usually end up with multiple layers of paint and collage both adding and subtracting until I am satisfied with the outcome. My final marks are usually accents or darks wherever I feel more emphasis is needed to make my final statement.

I usually give my work the test of time, keeping it around until I'm sure that I'm satisfied with the final solution. I then glaze the finished painting with a mixture of matte and glossy acrylic varnish to unify the painted surface.

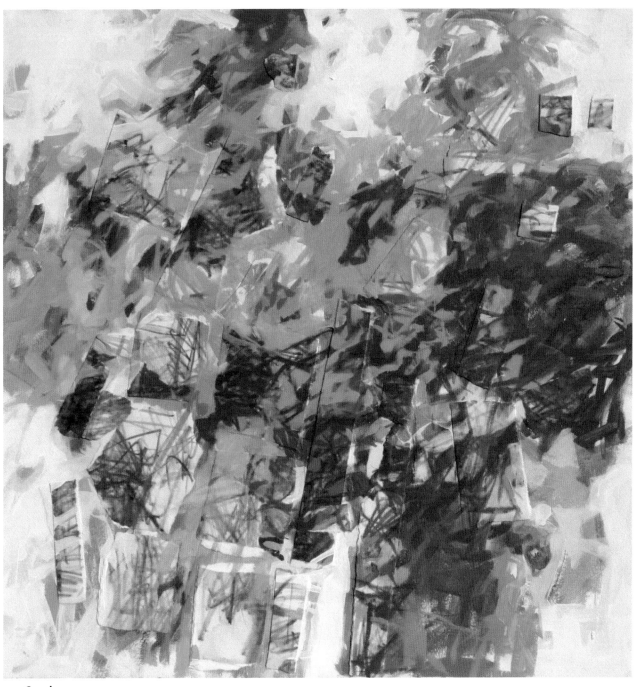

Smoke
By Kristi Galindo Dyson
Mixed water media with collage
30 x 30"

Joan Enslin, NWWS

Bamboo Forest is painted on Crescent HP Illustration Board, using mostly Daniel Smith Watercolors.

To begin this painting I covered the entire board with a warm color of Raw Sienna and let it dry. Next I added Ultramarine Blue and Cerulean Blue with a little Raw Sienna to form a cruciform composition. Dropping paint into a wet surface lets the paint mix together randomly. I continued this process until the values suited my needs. I then sprayed the upper corners with water and lifted with a soft brush to give a little more texture.

Next, using a damp brush, I lifted the color to see the painting beneath and to form the different vertical and horizontal lines. My image appeared. I used Lunar black to intensify and define the lines and to increase the look of bamboo. I added more Cerulean, Raw Sienna, Ultra and Alizarin to deepen the values.

After letting the painting dry, I viewed it through a mirror to check on the overall composition. I do this with all my paintings. Looking at your work through a mirror, reverses the image and it is much easier to find flaws in the composition.

I let the painting dry overnight. When I viewed the painting the next day I felt the painting was almost complete but needed additional brightness. I added soft pastel and ink to enhance the color and this brought it all together.

Bamboo Forest by Joan Enslin, NWWS
Watercolor, soft pastel, ink. 18" x 20"

This painting is small and was completed in a very short time. I used Golden Heavy Body Acrylic paint with water and matt medium to reduce the gloss. I put a coat of gesso on the canvas at an earlier time to let it completely dry.

I began by painting Quinacridone Azo Gold across the upper part of the canvas. Then I let it dry. I added Alizarin Crimson and Ultramarine Blue to the right upper corner to darken the edges, and to add a purple tint. While the painting was still wet I lifted and lightened the painting for the rising sun and proceeded to use Ultra Blue to darken the left upper corner of the painting. Mixing, directly on the canvas, Quin Gold and Ultra Blue with a little Alizarin, Cerulean and a bit of Burnt Sienna, I dragged my brush randomly across the upper middle of the painting making sure to leave some Quin Gold

showing. While the painting was still wet, I scratched into the paint finding the under-painting to give it texture.

After the paint dried, I used a mixture of Ultra, Cerulean, and little a Titanium White and Quin gold to the other parts of the painting also scratching into the paint. The painting was completed by adding Titanium White and Quin Gold and sprayed with water to let it drip.

I favor value, texture and line in most of my paintings. I paint experimentally with no pre-conceived notion as to the final result, and push the boundaries to achieve my own visual attitudes.

After the painting dried for a couple of days I sealed it with one coat of gloss varnish and followed with two coats with a mixture of one part gloss to two parts matte varnish.

Dawn
By Joan Enslin, NWWS
Acrylic
10" x 10"

Kay Fuller

Variations on a Theme:

The support for Numbers Game I is a piece of Illustration board. I used a paraffin block to coat the edges of the illustration board, so it would not separate while it was being painted. Then I coated it with thick white Gesso and used grooved scrapers, i.e. the kind used for drywall, to add texture. Other fun scrapers include sticks, forks and combs. You can also use textured cardboard, stencils, or papers to make designs in the wet gesso.

After the gesso was completely dry, about 24 hours later, I did an under-painting using fluid acrylic paints applied in a modified cruciform pattern. I used Golden Fluid Acrylics in Thalo Turquoise, Red Iron Oxide, Yellow Azo Gold, and Titanium Buff. I simply poured the lightest color paint onto the board and used a rubber-gloved hand to move the paint around. While the paint was still wet, I added darker colors and let the paints mingle.

When the acrylic under-painting was dry, I stenciled on a design by dabbing on a mixture of gesso, azo gold, and a hint of thalo-turquoise, using a cosmetic wedge sponge. I dabbed the paint on

Numbers Game I by Kay Fuller
Acrylic. Numbers Game I - 10" x 10"

and tissued some of it off with paper towels or crumpled tissue paper. I continued using stencils, covering parts with paint, until I got the effect I wanted. The last thing I did was to make the marks using the side of a credit card that I dipped into the light paint and touched onto the board, forming a grid pattern.

Two important things to remember when using stencils or rubber stamps, is to modify your marks to make them your own, and to wash the stencils immediately after using. Once the paint dries on the stencil, the design is never the same.

Numbers Game II was made in a similar fashion using a gesso-coated stretched canvas as the base. It was later embellished with a paint skin and a slice of agate. I often use pieces of glass, pottery, rust, jewelry, gears, etc. as embellishments in my paintings. The circles were made by dipping the cap from a soda bottle into paint and pressing it onto the painting.

Both paintings were coated with a gloss varnish medium when dry.

How to Make Paint Skins: I use butcher wrap as a palette. The paint that accumulates on this slick surface can easily be removed later to create paint skins. Coat the dry paint with gel medium. Once it is completely dry, carefully pull the paint up in sheets. The colors that are encased in the gel medium are beautiful. Most often they look like colorful slices of marble. They can be torn or cut into your desired design and adhered to paintings using GAC or diluted gel medium.

Numbers Game II
By Kay Fuller
Acrylic
12" x 12"

Joan Fullerton

I am a collector of vintage photographs, old lace, textured papers, quotes, buttons, stamps, rusted metal and other various ephemera. When beginning a new collage, I select a few items from this collection. My mantra being, "notice what you notice". It is never an accident what calls out to you!

For this collage, I drizzled washes of quinacridone/nickel azo gold Golden Fluid acrylic paint onto the canvas. This process tints the canvas and gets me excited. Watching pigment flow and collect into puddles and drips is my way of discovering subject matter and creating a composition. Rather than using a preliminary sketch, I look for patterns and shapes within the loose application of paint, and I begin asking "what if". Upon turning the canvas in all directions, I discovered what could be a figure standing vertically and decided to use one of my vintage photographs for a face.

I taped a piece of silk tissue paper with gampi onto a sheet of copy paper (taping all the edges, making it lay completely flat), and then ran it through my laser printer. When glued to a surface with gel medium, the tissue paper becomes totally transparent except for the dark ink, allowing underlying color and texture to show through.

I enjoy having a halo or arch around my images. To create this I used a paper doily as a stencil on a brown paper bag, spraying adhesive over the doily covered paper, and then rubbed loose sheets of gold metal leafing into the sticky surface. Excess metal leaf can be removed with rolled up masking tape. Using polymer medium I glued the gold pattern on brown paper to the upper left corner. The gampi paper transparency of the face was then collaged underneath the arch shape.

I decided to print my personal photo of red tulips onto Lasertran transfer paper, a product that makes transparencies quick and easy. I ripped the waterslide transparency into a skinny piece and a wider one bookending the figure, so that my "goddess" might seem to be enmeshed into a field of red flowers.

When the collage was complete, I drew a Tarot card, hoping it would indicate a possible title or provide me with more information about my image. The message received was about being in communion with flowers and becoming one with them! With a permanent pen, I wrote a quote from the card on silk tissue paper and collaged it into the art.

In order to add more texture and to further integrate the parts of the collage I took an expired credit card and swiped some venetian plaster (from the hardware store) over the image. I stamped texture into part of it with a metal screen, let it dry and tinted the plaster lightly with more fluid acrylic. Plaster is delicious to use; it adds depth and contrast to the transparent areas, and it feels like frosting a cake.

Creating art in this intuitive fashion is exhilarating because you never know where you will end up! Whatever shows up will lead you to yet another idea, and another.

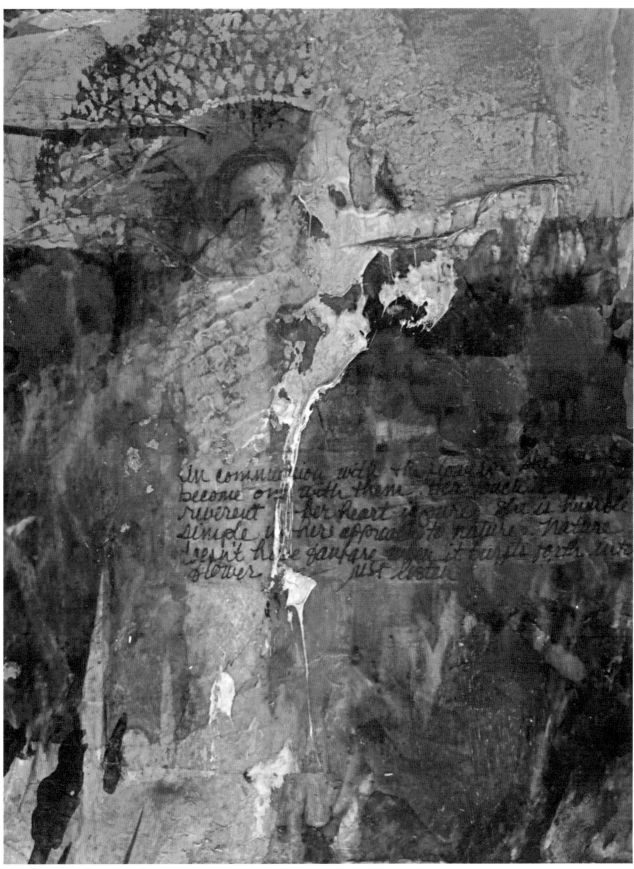

Garden Empress by Joan Fullerton
Mixed media. 14 x 11"

Judy Gilmer

On a white ground, I applied fluid paints beginning with Golden Quinacridone Nickel Azo Yellow, DaVinci Cobalt Blue, and Golden Turquoise. I covered a large area of the lower portion of the canvas with this mixture and brought a little of the same colors to the top of the canvas. The use of a flat wash watercolor brush allowed for the paints to glaze and glow.

To add a flat opaque surface for contrast, I used Liquitex Off White fluid paint and made some repeating shapes.

Now I introduced Golden Quinacrodone Violet and DaVinci Opus Pink, mainly in the upper right corner. Because there was some gold paint in the corner, the blue undertones in the pink and violet grayed it down to a lovely brown shade which helped to make a quiet area, without being opaque.

Note that I use the brush in multiple directions. The strokes may show a direction, but often in a "mish-mash" pattern, which creates texture.

Although the piece was quite colorful, I decided to pop some red on the surface over some of the quin/gold paint toward the center and in the upper right corner over the violet area. The underneath colors are allowed to show through. The red worked nicely, being in the same color family.

To define the shapes a bit more, I used a water-soluble pencil throughout the surface, and finished by adding a black painted area to keep it just a little quirky.

Sugarcane and Summertime Days
By Judy Gilmer
Acrylic
36 x 36"

Madelaine Ginsberg

In this painting my intent was to express the colors and shapes of Santa Fe following a visit to that city. Using a more formal, geometric design, I painted alternating layers of transparent wash and dry brush using two and three-inch brushes. I used many layers of color in order to achieve a richness and depth to the painting. I wanted to show the earth tones, turquoise accents and red colors of that area in shapes resembling the homes and outdoor spaces that I remembered. By arranging larger, more flat tones against smaller and brighter colors, I wanted to portray the variety of textures and forms that I saw, from buildings, plants and grasses to sky and stones. Final touches were painted with smaller, fine-pointed brushes.

Santa Fe #1
By Madelaine Ginsberg
Acrylic
16 x 20"

I paint in an experimental style, which is more of a mindset than a method. Rather than having a formula that would guarantee a particular outcome, I work in a way that allows me to try new techniques and to take a risk with ideas and concepts. I use heavy body acrylic paint in jars on a wide range of surfaces: primed and unprimed canvas, Masonite, wood, mat board and Arches cold press 140 lb. watercolor paper. For the unprimed canvas, Masonite and wood, I paint or sponge on one or two coats of white gesso to seal the surface before the actual painting process begins. I usually paint with two-inch or three-inch brushes which allow for more freedom. Since I am hard on brushes, most of the ones I use are inexpensive bristle brushes from Home Depot. I do have a few one-inch bristle blend brushes which I use for some of the wash layers. I use #2 and #4 round brushes for the final details. My first move is to eliminate the white of my surface by using a large brush and layering on washes of transparent color over the whole canvas or paper. I use a dry brush technique to paint in areas over the transparent washes, then more washes followed by more dry brushed layers to achieve multi-dimensional layers of texture. I contrast this with fine line brushwork to outline or bring out certain features in the painting.

Regarding subject matter, I am intrigued and moved by the natural world, from the tiniest plant or insect to the mighty canyons and vast seas. Always there is the thread of the actual landscape—wind, water, mountains, trees, land forms—weaving through the abstract to give rhythm and pattern to the artwork. My aim is to show the flow and movement of colors and shapes as they interact, merge and transform.

Often I'll have a general idea of what I'd like to depict, such as mountain ranges, trees or bridges. Or I may have visited a particular locale which stimulated my creative juices with its unique colors and forms. I have learned over the years to allow for changes or so-called 'accidents' to happen which can lead me in an entirely new direction. Sometimes I've tried to forge ahead with my original concept and find that the painting is insistent on taking me another way. I mentally dialogue with the artwork to find out what it wants from me and I do get answers to my queries. When I follow the painting's lead, I am more likely to end up with a successful outcome.

In "Winter Morning" I painted on three 16 x 20" canvases which I later joined together. Placing them flat on a table next to each other, I applied thin washes of transparent acrylic using phthalo blue, cadmium orange and cadmium yellow light. The layer of white was also applied as a thin wash allowing areas of the blue, orange and yellow to emerge. Often I blot the wet paint to allow the underneath colors and shapes to appear. For the darker blue areas and line work, I mixed phthalo blue with burnt sienna for a deeper tone. I used one of the fine-pointed brushes for the gestural and linear work at the end.

**Winter Morning
By Madelaine
Ginsberg,
Acrylic,
20 x 48"
(Triptych)**

Sue Hamilton

A trip to New York City to see the American Watercolor Society's show and the SOHO art galleries was the impetus for this painting. Being in the city always energizes me. At the time I didn't realize how the trip would end up in my painting. Shortly after returning I started this painting in my usual manner by deciding on a color scheme and thinking about what I really liked in the previous painting. The last painting had a black background and cream middle. This time I reversed the process by painting a cream background and a black middle ground.

I started with a cruciform design in mind and scraped across the canvas by applying black gesso to an out-dated credit card. Immediately, I liked the shapes, textures and open spaces this created. Next I randomly filled in a number of the white spaces with a variety of Golden Fluid Acrylic Quinacridone/Nickel Azo Gold acrylic and Liquitex Soft Body Naphthol Crimson acrylic. Then I mixed white gesso with a very small amount of Quinacridone/Nickel Azo Gold to get a cream color and using a painterly stroke applied it to the top and bottom of the canvas with a brush. Stepping back I studied the canvas.

Things weren't working well enough for me yet, so I tried adding a Cobalt Turquoise accent line near the bottom middle, and toward the top left to see if I liked it better. Later I took the bottom turquoise out as it was too distracting. I varied the Nickel Azo Gold by mixing it with Naphthol Crimson at the bottom right and painted in some interesting shapes. Some white gesso rectangles were added at the left to create some tension. I varied them with Naphthol Crimson, and Pyrrole Orange. Next I applied some cream-colored gesso with one side of a tile applicator to a small square in the center to create some lines. When it dried I stamped over it with black gesso. Only the top of the lines got coated creating the black. Then I stamped the center with black to create the little squares. At this point my painting needed to dry, so I took a break to let my creative juices do their magic while I attended to life's other duties.

During my break, I thought about this painting a lot and looked at books, other paintings of mine, a few galleries, and web sites. Finally it came to me. Why not add one of my favorite poems. Taking a piece of freezer paper and a permanent black ink pen I wrote the first verse. Then I tore around the edges to make it uneven and applied it to the canvas with white gesso. By painting out some of the words the poem becomes more interesting. A splash of orange and black gesso mixed with white to make gray placed in and about the poem finished it. Next I painted over the area directly under the poem with heavy cream-colored gesso and used a different edge of the tile scraper to create the wider lines that showed the previous stamping through it. I painted out previously stamped sections along the side of the black squares in the center and added some cream-colored gesso in a crisscross pattern. I also painted out some black stamps above the poem with the cream mixture. When I did this a few drips ran down next to the scraped area, and I liked them and left them. Then I tore out a small section of print from a magazine, pasted it to the left to offset the poem, and covered it with a thin coat of gray.

Next I added a half circle with Golden Fluid Pyrrole Orange and Naphthol Crimson and highlighted it with a touch of Cobalt Turquoise. Then I added a few Naphthol Crimson lines above the circle. A full circle was added at the top left in Pyrrole Orange, and Liquitex Prism Violet mixed with a little Naphthol Crimson. I put wide lines of Pyrrole Orange in the center.

The center bottom originally contained black credit-card scrapings. But I wanted to vary the cruciform shape, so I painted most of that out

with the cream color. Then I scraped more black gesso at the bottom right. I also did some black gesso scraping on the lower left to balance the painting, and painted three little black squares in the bottom left middle to activate that space. I finished by spraying the painting with an Grumbacher Gloss Varnish spray to give it a slight sheen.

Although I did not try to paint New York City I believe it did show up in my painting. You be the judge.

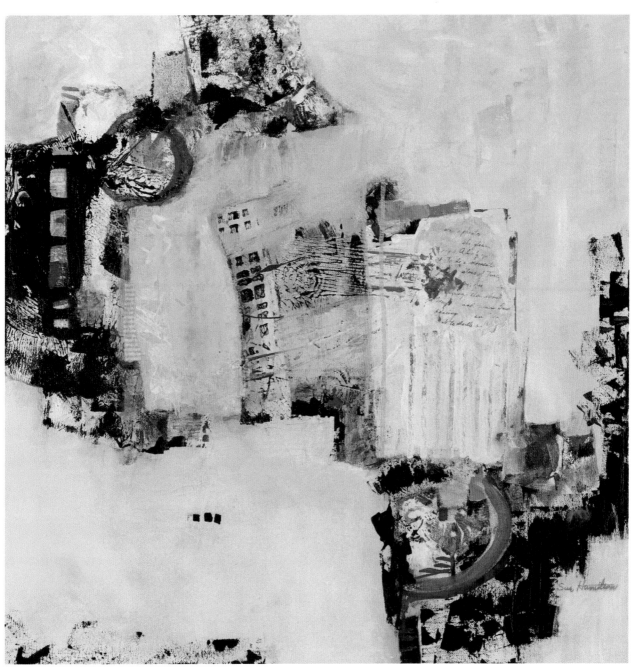

A New York Frame of Mind
By Sue Hamilton
Acrylic/Collage on Artist Loft Cotton Duck Canvas
24" x 24"

Until recently, painting in bright colors has been my style. But today was different. I decided it was time to create a painting primarily in black and cream just for the challenge of it. Since the way I usually start a painting is with a color scheme in mind, I already had a starting point. I began this painting by applying black gesso to an outdated credit card and scraping it against the canvas to create some uneven interesting shapes. At this stage I didn't have a design plan. Then I painted some of the middle part of the painting with a mixture of Golden Fluid Acrylic Quinacridone/Nickel Azo Gold paint and white gesso to make a cream color.

With the cream and black colors applied to canvas the design started to take shape. Now I can have some fun with my stamps. I create these stamps from Styrofoam takeout containers from restaurants. Using a chop stick I make indentations in the Styrofoam to create interesting designs. I get my ideas for these designs from many different sources—clothing, wallpaper, upholstery, draperies, magazines, nature, etc. After mixing the black gesso with a little white gesso to create a gray, I apply it to the stamp, place the painted stamp on the canvas and roll over it with a brayer. Voila, the design is transferred! Another way I use my stamps is to apply a dry stamp to wet paint, roll it with a brayer, and lift off some of the color so the underpainting shows through. I also like to use the same stamp with the opposite color such as I did in the cream square on the black on the left side with the black squares beneath it. I have also repeated this design on the right and in the middle. In doing so, I encourage the viewer's eye to move around the painting. At this stage I continue randomly stamping with different variations of the black, cream and Nickel Azo colors without giving any thought to the final design. The aim here is to just relax and have fun.

With a wide variety of stamps applied, it is time to stand back and try to figure out where this painting is going. What's working and what's not? Is there variety, texture, direction, dominance, interesting places to look? The painting seems to be interesting but I am not sure exactly what I need to do to complete this work yet. It was time to put it aside and think about it. In the meantime I would look at good art books, galleries, web sites, and my other own works of art. With Christmas fast approaching, presents to buy and cleaning to do, there was no time right now. And after Christmas it was time to go to Florida. This painting sat alone in my studio in Virginia until April when I returned from Florida.

While in Florida I worked on a number of other paintings. When I returned and looked at this painting with fresh eyes, I decided it needed a little more color. I filled in some of the black stamped areas with Liquitex Naphthol Crimson Acrylic paint. Using the same red, I stamped the painting in a number of places. Next I applied some Golden Fluid Pyrrole Orange paint to a spot near the bottom for accent. Then I added a little Liquitex Light Blue Permanent acrylic paint to a couple of spots, and some Golden Fluid Iridescent Gold (Fine) paint for interest.

I finished the painting by eliminating some of the stamps with black gesso. I decided to leave the three little white squares near the bottom right side for fun. Then I activated the surrounding black areas with red stamps and brush strokes. Lastly, I sprayed the entire painting with varnish to give it a sheen and create harmony.

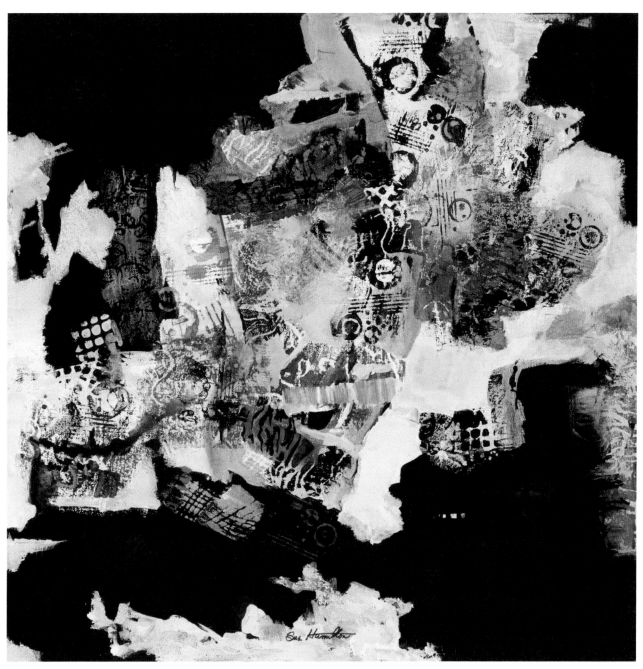

Black Gold
By Sue Hamilton
Acrylic Paint on Artist's Loft Cotton Duck Canvas
24" x 24"

Karen Hansen

Counting Breaths is a visual interpretation of the process of meditation. I meditate routinely and the content of my paintings frequently refers to different aspects of that experience. At the beginning of a meditation session my mind is filled with clutter. As I begin focusing on my breathing, my entire body relaxes, my meditation deepens and my mind clears. This piece explores that progression.

The painting is presented on five wood panels, each panel measuring 8 x 20" with a 2" cradled edge. My husband builds the supports for me out of birch plywood which allows me to easily request custom sizes. Wood panels are commercially available as well. I love to paint on the hard, smooth surface of wood. The experience is totally different from painting on canvas which has texture and responds to pressure.

I began the piece by priming the panels with two coats of gesso which sealed the wood and gave me a beautiful, clean surface. Then I started applying paint directly to the panels, straight from the tube or jar, mixing colors right on the painting. I moved the pigment around with brushes, brayers, palette knives, and a spray bottle filled with water. Using acrylic paints both allows and requires me to work very quickly, mixing and blending as I work. This is vital to the softness of the finished piece. I used paper towels, both dry and damp for dabbing and softening edges. My palette for this painting was limited to warm earth tones: cadmium orange, raw umber, burnt sienna, paynes gray and lots of white. As I worked, these were diluted with acrylic medium as well as water. The paint was applied in very thin layers, building the surface slowly and allowing the underlayers to show though, lending depth and subtlety to the surface. I started on the bottom panel where the most detail and variation occur. I progressed to lighter and softer coloring as I worked upward.

I work on an easel that can be adjusted to any angle so that I can paint flat, essentially at worktable height. With the easel in that position I was able to place all the panels abutted together so that I could see and work on all of them at the same time. Working flat is also imperative since my process involves using lots of water.

Once the face of each panel was finished I proceeded to paint the edges of each in a continuation of the same colors and patterns that appear on the face. This allows the piece to be hung without framing. The sections are intended to be hung with a one inch space between each panel. A coat of varnish protects the piece.

Counting Breaths
By Karen Hansen
Acrylic on birch panel
44 x 20 x 2"

I started Dusk with no preconception, beyond choosing a few favorite colors with which to begin. I frequently approach a painting without direction. I enjoy the adventure in the process of painting, allowing the piece to evolve, responding to what I see happening before me. There are many variables to creating a painting and I love "pushing" them all, experimenting as I go, always asking, "What if?" I revel in the unforeseen results between my paints, my tools, my application approaches and my impulses. I quiet my inner critic (left brain) and paint intuitively (right brain) for much of the process. And I love working with acrylic paints. With acrylics there are no mistakes! Disasters can all be covered over quickly.

The piece was created on Strathmore Aquarius II watercolor paper. It's a lovely, smoothly textured paper that doesn't buckle when it gets wet because it's made of cotton and synthetic fibers. It offers a wonderful surface on which to paint. For this piece I used a quarter sheet, measuring 15 x 11". My first step was to apply a coat of gesso to the paper. This seals the surface, keeping the acrylic pigment from sinking into the fibers and insuring that the colors remain bright and lively. It also allows the paint to remain workable longer in the painting process.

I began the piece with quinacridone gold and Jenkins green. As things started to take shape I added other shades, azurite hue, light blue permanent, and a few touches of light blue violet. These were all diluted with acrylic medium and spritzing water from a spray bottle as I worked. The paint was applied with brushes, brayers and palette knives. I used paper towels to dab passages that were too strong and blend hard edges as I worked. I also used paper towels to remove sections of wet paint to reveal underlayers of color. I typically work very quickly so that my paints remain workable until I'm ready to stop and assess the piece.

As I worked, some interesting passages occurred. The left side had a stained glass glow about it that I wanted to maintain. It was created by painting quinacridone gold which is a transparent, staining pigment. When the passage was nearly dry, I sprayed water on it which moistened the surface of the pigment. With a paper towel I was able to lift these wet spots. What remained was the light yellow stain of color where the water droplets had fallen. The drips in the lower right were "happy accidents" that I always welcome and encourage in my work. They were created by water dribbling through pigment that was nearly dry.

My final assignment was to find a proper title for the work. The colors and movement of this painting created a moody abstracted landscape, with a light quality similar to the moment just as the sun disappears behind the horizon. The title was Dusk.

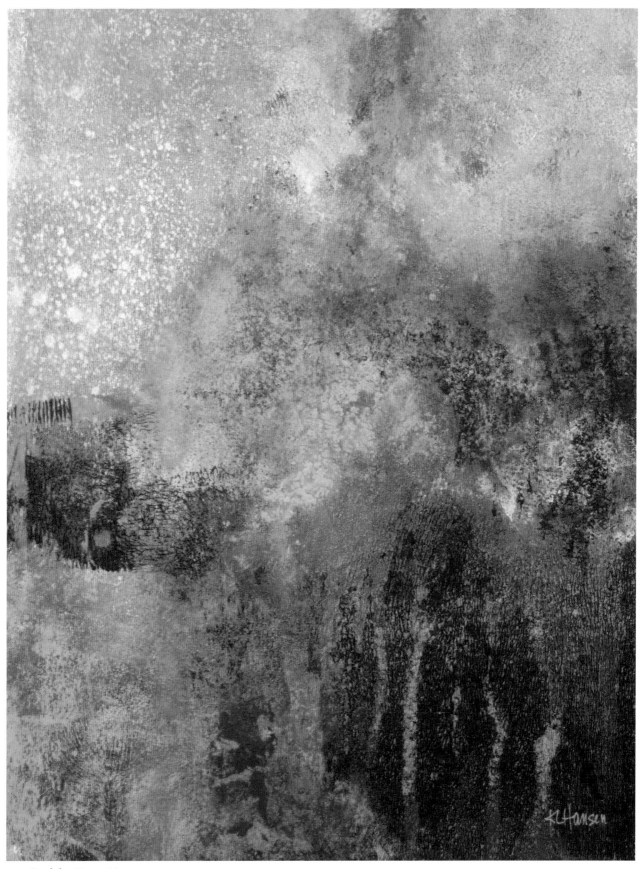

Dusk by Karen Hansen
Acrylic. 14 x 10"

Kathryn Hart

This painting is part of my "La Luna Negra" series which explores my reaction to my mother's death and its impact on my identity. The first and most important step to this painting is my idea. The figure is either constrained within the shape or emerging out of it and moving towards something.

Knowing that I would be collaging weighty materials, I chose to use board as my surface. Plus, I like its immediate feedback. I started by building up the surface with corrugated cardboard, plaster-type materials, paper-mache' and other materials in a general abstract shape which I would use later. I also collaged some of my mother's sheet music and other materials which would move through the figure and transition the abstract shape with the rest of the painting.

I began painting with the deliberate choice of neutrals and more saturated color for the blue shape on the right. I first lay down lots of acrylic paint, gesso, crayon and other media, painting freely while moving, editing and scraping away. I had the general shapes in my head, so it is all possibilities at this point. I painted until I thought it was time to stop. The next day, I realized that the painting needed more...a crustier surface with history and tension. It looked too slick. Additionally, the corrugated cardboard was not incorporated. I wanted lost edges and for it to look like something had crumbled away on top of it. To achieve this ef-fect, I needed to apply more plaster-type materials over what I had already painted the day before (and rather liked). Additionally, the painting had too much transparency and I wanted a created surface with only a little depth and translucency closer to the surface. So I repeated my first day's effort, completely covering the painting with paint and other media without totally losing the impression of the sheet music underneath. I worked until the painting needed to rest.

Now, the figure needed adjusting so it was barely there, yet had some substance and energy. I wanted tension between the figure and the shape of which it was a part. How much to show, how much to lose, which edges would remain...I worked for a while on these. I also did not want the textural shape on the left to be too similar in shape to the blue one on the right. Now I had to ensure that the surface quality was consistent, that one element didn't stick out from the rest unnecessarily. I also worked to get a feeling that the blue shape was separate shape, almost its own world, yet offered entry, so edges and transitions were very important.

In my final steps, I dripped the bronze line into a wet surface, connecting the abstract/figure shape and the blue shape. A few other drips, splatters and adjustments followed to incorporate the line and make sure it did not just sit on top as an afterthought. I stopped when it felt right and conveyed my intention.

I Hear the Notes but There's No Music
By Kathryn Hart
Mixed Media
24" x 30"

This painting began like all of my paintings: with an idea. My paintings are typically emotionally-driven, and this one was as well. Journey is part of my "Mind Mapping Series" which is about my grappling with my mother's Alzheimer's dementia and her journey. I had this idea that a memory bank is a big mesh of threads, each one a different memory. Which ones are lost or become frayed or entangled with others is mysterious and unique to each person.

I began with a piece of unstretched canvas that I did not pull tight so that it would warp unpredictably. I played with pieces of different collage materials which supported my idea…cheesecloth, frayed material, sanding paper, and some hardware to get an idea of the general shapes which felt right. I first collaged the cheesecloth into general shapes in a haphazard manner, ensuring there were wrinkles, pockets of untouched material and lots of strings hanging about. Once that was dry, I was ready to paint.

I used different acrylics, some watercolors and other media and began painting. My palette was very limited and I used only gesso as my white to achieve a soft, matte finish. I am loose, gestural and sloppy at first, thus I paint flat on the floor. The paint does not run off the bottom but stays on the surface to be pushed around, messed with and painted into. This also means that some parts of the painting dry at a different rate than others, so I can paint both wet-in-wet and over dry parts of the painting with the same brushstroke.

I painted over the entire painting for an entire session until it felt like it needed to rest; I painted again in a different session to add, subtract, alter and achieve more depth and history to the painting. My idea called for an almost all white painting atmospheric, ethereal depth, plus an aggressive part of the painting.

Once the painting was dry again, I collaged the remaining pieces – sanding paper, hardware, unprimed canvas and the louvered pieces made out of cardboard and cloth on the upper left. I painted again to incorporate these pieces and make more changes I felt were necessary to the rest of the painting, using paint, watercolor crayons, charcoal and other media. I did a lot of splatters and drips as this was in keeping with the frayed edges of memory. Following this, I felt the dark piece on the right side needed more strength, so I darkened it further. I scattered some rusty nails across the top portion and made more adjustments until the painting felt right and said what I intended.

Memory Threads
By Kathryn Hart
Mixed Media
34" x 36"

Cathe Hendrick

The techniques and materials I use generally depend on the size of the piece and are often varied and unconventional. At times I've used print-making, sculpture or fabric applications to get the desired effect or to see what effect might develop.

In this piece I chose to use a lightweight Fredrix canvas. I stretch my own canvas because I like the matte and absorbent quality of the surface. I also do a gallery wrap so the edges can be painted and give the piece a sculptural feel.

After the canvas is stretched and a coat of gesso is applied I wait about 2 hours for it to dry before I lightly sand the surface.

In my abstract pieces I like to start with a foundation of color so there is a layering effect. In this painting I randomly added specific colors that I wanted to show through.

This painting was not about unusual technique, tools or material but about an emotional journey. This piece was an adventure back in time to the house I lived in from ages 4 to 17. The colors in this house have had an impact on my art and I've wanted to express this for quite some time. I feel this was my first successful attempt at expressing the interior colors of my childhood.

The final application of paint was an intuitive exercise in editing colors, exaggerating some things and omitting some details. Wassily Kandinsky said "Of all the arts, abstract is the most difficult. It demands that you know how to draw well, that you have a heightened sensitivity for composition and for color, and that you be a true poet. This last is essential."

Behind Closed Doors
By Cathe Hendrick
Acrylic on Canvas
24" x 20"

This piece was painted on Arches 300 lb paper using watercolor paints. I started by very lightly drawing a general design on the paper using a drawing pencil. The idea was to combine the idea of a rose that would morph into the feeling of landscape. The basic design was a series of angular shapes that were softened with some curved lines.

The next step was to start applying paint. My process when using 300 lb paper is to use a wet-on-wet approach, which means applying the paint onto a wet surface. With a flat brush I wet one of the shapes and then applied the color. The result of this approach is a very soft look and is conducive to blending and shading. I go on to another shape that is not adjacent to the shape that was just painted in order to avoid bleeding. I cover the entire painting using this approach.

Next, I enhanced color by adding another layer of paint using the same method of wetting one shape at a time. This time when I wet the shapes I went a little bit over the edge. This will soften the edges.

Then I added shading and a sense of depth. Using the same method I wet one shape at a time but this time I used a darker color or complimentary color to the areas that I wanted shaded. The dark color stays where applied but the edges are soft and blend because the shape is wet.

The last step is to wet larger areas and add color. This makes the color more saturated and also helps to soften and unify the painting.

Rose Landscape
By Cathe Hendrick
Watercolor
15" x 11"

Susan Eleanore Hensley, SEH

On this piece, "Boutique", I started by placing geometric shapes on my watercolor paper (watercolor paper, 140 pound, cold press, Strathmore). For example, the rectangle in the upper left hand corner is a small piece of an old 'failed' painting. The other squares and rectangles are bits of copper tape I bought from a hardware store. After establishing these in a random fashion I added circles and spheres in Prussian blue acrylic paint.

The more I looked at "Boutique" the more I saw elements of the actual boutique I had previously owned, "The Sickle Moon". I could see a vanity, some chairs or seats and some mirrors. This was great fun and making this was a lot like playing. The addition of burnt umber and black acrylic paint anchored the light gold and pale blue colors which dominate the piece.

Several years ago I won an Honorable Mention for "Boutique" at an outdoor street fair in my town and I almost didn't bring it to the event. Since then, however, I've studied it more, trying to see what the judges may have seen in it and it fascinates me even today.

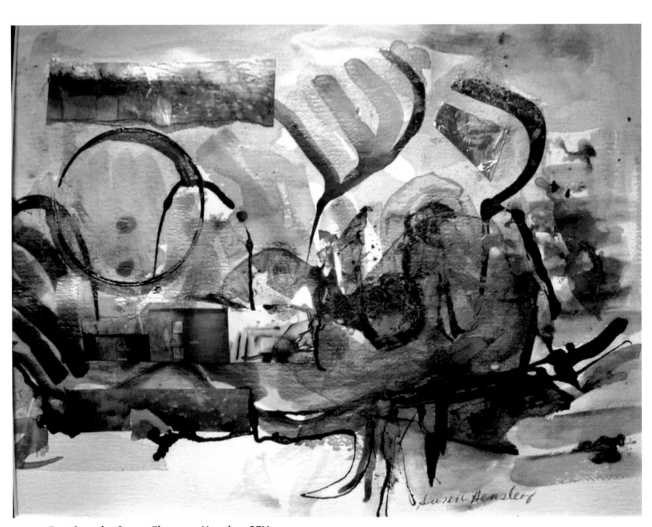

Boutique by Susan Eleanore Hensley, SEH
Mixed media: acrylic paint, old painting pieces, copper tape. 17" x 20.5"

First, I took my studio stretched canvas (100% cotton, acid free, kiln dried) outside on what I thought was a clear windless day in fall. I poured and dribbled craft glue onto the canvas. In my level back yard I stood on a small step stool and dropped several of the media listed above and dropped the small and medium pieces onto the canvas without any specific intent. After performing this action for about 15 minutes, I realized a little breeze was starting up and this forced me to go back into my porch studio.

Second, I continued to drop media onto the glue canvas until I had a base to work with and then positioned the media pieces with a No. 10 soft flat rubber chisel by Forsline & Star. Before the glue dried I had ample time to change the direction of several pieces but made sure many of them stayed in their original random positions.

Then I let this dry overnight. I visited it from time to time viewing it from different angles and from vertical to horizontal points of view. The digital photos I took of its journey and which I looked at in my computer were most helpful--it was a very different point of view looking at the piece through a digital photo. I highly recommend this exercise.

In the later stages of the journey I endeavored to balance the dusty drab pieces of media--eg. dead leaves and plant material with bright orange pieces of paper, doilies, and shiny pieces of metallic material--eg. copper leaves, silver and gold acrylic paint. I think the bright parts slightly outnumber the drab parts but I haven't [and won't] count them. Finally, I sprayed the piece with gold metallic paint as a fixative. Emily Dickenson's poem, "Hope", seemed an apt title.

Hope by Susan Eleanore Hensley, SHE.
Mixed media: leaves, lace, copper, plant material, photos, acrylic paint, ink, oil pastels. 30" x40"

Carlynne Hershberger

When working on art pieces as large as 36" x 36" I like to use gallery wrap canvas. The sides are staple-free so I extend the design and color onto the sides. This way the painting can be hung without a frame. I also like the sturdiness of the deeper canvas - less chance of the canvas warping over time.

Many of my abstract designs begin with natural forms. In this particular series I began with satellite images of earth. I use these as ideas for color and pattern. I began by toning the canvas with orange acrylic. I used a large brush and moved quickly. For this step I like to use a soft body paint that spreads easily. Sometimes I'll use a spray bottle with water to give the canvas a mist and move the paint across the surface. Once this first layer of paint is dry I pull out the tissue paper. I use plain white paper only as the colored tissues will bleed color. I tear pieces of the paper into rough shapes in a variety of sizes. I crumple them into little wads and then open them up again. I use acrylic medium as glue. I brush some medium onto the canvas, take one of the pieces of wrinkled tissue, apply it to the canvas and then brush more medium on top to seal the paper to the surface. When I'm applying the tissue I take care not to smooth it out too much. I want the canvas to have some texture to it so I let the tissue overlap here and there and remain wrinkled. I move from section to section until I cover the whole canvas including the sides.

I wanted to keep the colors in this piece on the cool side so I used a variety of blues and violets and let the some of the orange background come through for contrast. I usually use complimentary colors in my work. I find it gives it a little bit of a spark. I use the background color to my advantage by applying thin layers of color on top and then wiping back into the layer to reveal the color underneath. Sometimes I drybrush the contrasting color on top. Drybrushing also helps to accent the texture that the tissue paper created. So, I continue brushing and wiping various shades of blue and "finding" shapes within the texture of the tissue. In some areas I left the white of the tissue for an accent.

Now I'm ready to do some linear work. On the left side I wanted a vertical area that was more defined and ran from top to bottom on the canvas. Thinning the acrylic with a little medium and water and using a liner brush I painted some lines, again finding shapes to outline. Once I have my lines where I want them I decided to punch up the color. Most of the canvas is in soft, muted tones so I wanted to bring more attention to that vertical area. I used turquoise and deep violet to bring out the focal point of the painting.

Once I reach this point, I put the painting away for a while. After it's been hidden from view for a couple of weeks, I bring the work out and look at it again. It helps to have a fresh perspective. Then I decide if there's anything else I want to add to the piece. If I can't think of anything else that would improve it, I call it done.

Earth Passage
By Carlynne Hershberger
Acrylic and tissue paper on Art Alternatives gallery wrap canvas
36" x 36"

Donna Holdsworth

I began this painting on a 1/4 inch wood panel. This can be purchased at your local home improvement store in 4 x 8 foot sheets and cut to your specifications. I have done this process on stretched canvas as well, but if the painting is larger I feel the wood is a more substantial support. Like stretched canvas, wood panels can bow. Check to make sure your panel is straight by holding it at eye level. If you notice a slight bow it can still be used, but work on the side opposite the bow, arched side up. Anything more than a slight bow should be cradled.

The first step in this process is to apply texture to the panel. There are many acrylic mediums that can be used, but in this case I used joint compound. It is ready mixed and can be bought for a fraction of the cost of acrylic mediums at your local home improvement store. I find the easiest way to apply this is with my hand, but you could also use a trowel, spatula, etc. Have a container of water nearby and just start smoothing the joint compound on the support. I add small amounts of water with my hand until the joint compound is as smooth as I'd like. Do not make this layer too thick or cracks can form. I think a few small cracks are okay but this is a personal choice. Also, be sure to throw the water outside when finished, as you do not want joint compound in your drain! Dry flat for at least 24 hours. When the surface has dried, I gently sand off any sharps with a drywall sponge. This can be done within minutes and it makes your finish much smoother. I then seal the painting with one or two coats of Liquitex gloss medium and varnish.

When the gloss medium dries, I do my dark underpainting around the edges and at the bottom 2/3 of the painting. At this stage I decided to apply just a sparse amount of the joint compound to the bottom portion for texture, letting parts of the underpainting show through. I sculpted the trees out of joint compound with a palette knife, impressing a damp doily into the tops for texture. I let this dry thoroughly and then resealed it.

Next I painted the sky. When I was happy with this, I applied acrylic washes to the rest of the painting using Golden fluid acrylics and a small amount of water. I find a 3-inch flat, synthetic brush works best for this. I used Ultramarine Blue and quinacridone/nickle azo gold, but you can use any colors you wish. Apply the transparent washes until you are satisfied with the result. Keeping the light source in mind, I removed some of the washes from the tree tops by blotting with damp cheesecloth. I then painted the tree trunks using a mix of burnt umber and ultramarine blue. Happy with the results, I apply one last coat of gloss varnish to protect and voila'! Your masterpiece is complete!

Copse by Donna Holdsworth
Acrylic/Mixed Media. 20 x 16"

I created this painting on a 1/4 inch wood panel. This can be purchased in 4 x 8 foot sheets and cut to your specifications at your local home improvement store. This painting can easily be done on any substrate you choose.

I began the process by collaging various papers to the panel using Liquitex matte medium. I use tissue paper, fiber papers and even packaging paper. I use white, cream, ivory or tea stained papers. I do not use colored papers unless I paint them. The most important thing to remember when collaging paper is to make sure you apply enough matte medium so that you get good adhesion. Also be sure to remove any air bubbles with a brayer or work them out gently with your hand. You do not want air bubbles under your painting!

Once this dried, I did my underpainting. I applied the acrylic paint darker along the edges and lighter as I worked in. I then collaged bits of fabric across the high horizon using gloss gel medium. Let dry.

Now the fun begins! I mixed my own colors on my palette using acrylic paints. I mix heavy body tube paint with fluid acrylics because I wanted thicker texture here. Fluid acrylic would be too thin on its own for this. I applied the paint across the focal area with a palette knife, letting each color layer dry before applying the next. Don't be too neat. Have fun and use different shapes. Make scratches into the paint with the tip of the knife. This step gives me an idea of the color ratio I will need in the end.

After this I made a mixture of gloss gel, matte gel and a scant amount of Golden titan buff. I applied this mixture to the entire painting, excluding the focal area, with a palette knife. When this layer dried, I applied the same mixture in a random pattern at the focal area, cutting in above and below to join the two areas together. Let dry.

The last step in this process is applying more color layers to your focal area. I used the same application technique as before. This time, however, after I apply each color I use damp cheesecloth to blend a bit of the paint into the quiet areas to bring the piece together. I use cheesecloth because it doesn't have lint. I have also seen this done with a sea sponge.

Finally, I applied UV Satin varnish to protect the painting. Your masterpiece is complete!

Righteousness
By Donna Holdsworth
Acrylic/Mixed Media/Collage
20 x 16"

Terry Honstead

I started this painting with an idea to express who I am and where I came from. First I looked through my old baby book with the idea of using some of the contents for a mixed media piece. I also used a picture of a ferris wheel from public domain. To me, this represents my ancestors because my Dad's parents were part of "the carnival" and I remember being allowed to ride at the small carnival that was set up every summer in their home town (and now mine) of Bemidji, MN. That ferris wheel represents all of my childhood memories of vacations and holidays that I spent there and in an even smaller town of Saum, MN where my other grandparents lived!

Also included in the mixed media pieces that I used are my third grade report card (because for some reason that has been a year of my life that I remember more clearly than most) and a picture of myself at the age of 6 months that my parents have had hanging for as long as I can remember. To me, those are the most important parts of my childhood and represent my core.

I also found several printed word pieces such as a dictionary meaning of family, and other objects that had meaning for me, and put those onto the background canvas with the more important ones. I "glued" them onto the canvas with acrylic matte medium and covered them in another application of the same. When that was dry, I also wrote "First Think! Second, Believe. Third, Dream". And finally," Dare!" as a reminder to myself to dare to think out of the box with my art!

Then, to start the color, I glazed over the whole thing with my favorite color, quinacridone nickel azo gold. When that was dry, I used bubble wrap with sap green hue to stamp my flowers onto the surface in random spots. I glazed more green around the flower areas to let them stand out and added stems. I also shaded the bottoms of the flowers with quinacridone crimson. I stamped my name onto my painting, although to make it more discrete, I put the TE in one area, and the RRY in another. I did not want people to know that this was a painting about my life until they looked into it more closely! Lastly, I added gold mica flake to highlight the flowers. Most people that see this painting see the abstract flowers, but if you look closely, you can see right into me.

Summer Blossoms by Terry Honstead. Acrylic/Mixed Media. 40" x 30"

Being enthralled with the idea of acrylic paint being a liquid plastic and the fact that it will peel off of freezer paper, parchment paper and plastic, I decided to test this out further. I found that plastic leaves an uneven surface because of wrinkles and parchment paper may leave larger "rifts" in the page due to expansion and contraction of the paper when wet. With this idea in mind, I stapled some parchment paper to plywood.

Then, I applied the paint with a large spatula to the surface, using both bright colors and metallic colors. I used 2 to 3 colors on each surface that I had prepared. I tried to mix in the colors so they would both be apparent, without mixing them so much as to change the original color of each.

When these were dry (and I did find it took a lot longer to dry than I had hoped!) I peeled the acrylic paint off the parchment paper and left it laying on top of it until I was ready to use it. To store what was left after my painting was finished, I left each remaining piece on the paper and then rolled all up together into a tube which will store in a small drawer that I have.

I looked for the most interesting parts of each "slab" of color and began to cut and tear bits and pieces for my painting. I used some uneven edges as well as some straight cut pieces, arranging them into an abstract landscape. I loved the way some of the pieces looked like grasses or reeds so I used that as the main concept of my painting. I cut some of the pieces to represent trees and even used an edge torn out for a tree stump.

After most of the idea started to gel in my head from the assembled pieces, I started the process of "gluing" them to my canvas. I used regular gel medium to adhere the larger background pieces, cutting or tearing spots that I felt needed it.

With the background done, I added the cut "tree branches" by heating up the acrylic on the background as well as the cut piece. When hot they adhere to each other fairly well. In places that they didn't want to stick I used more of the gel. For the last finishing touch, I put on a branch that I twisted so the viewer could see that something was different about this painting. Although it is completely acrylic paint, it is used differently than most people expect when they think about an acrylic painting.

Water Grasses
By Terry Honstead
Acrylic on Canvas
20" x 24"

Tis Huberth

I never begin a painting with a plan. Each painting starts with the application of many layers of paint in order to develop a really rich-looking surface. This painting was no different and it actually took many months before I decided on its final design.

My working surface for this painting was Strathmore Aquarius II, 80 lb. paper. I prefer this paper for my layered art. No matter how many layers I complete, the paper never buckles and does not need to be taped or clipped during the painting or drying process. Due to the lack of sizing in the paper and my process of applying many layers of paint, I first coated the paper with one layer of acrylic matte medium. This allowed the paper to be sealed, eliminating any initial absorption of the first layer of paint.

For the first paint layer I chose three colors - quinacridone crimson, phthalo turquoise and quinacridone gold. The paint I used was airbrush or diluted fluid acrylic. For the first 7 or 8 layers I used the most transparent colors, varying the combinations of reds, blues and yellows, thereby creating the effect of great depth while maintaining the transparency of the paint. The paint was applied by dropping the colors onto areas that were first wetted, creating channels within which the paint runs freely. By not wetting the entire paper and tilting the paper, I controlled the extent that the colors mixed and mingled. Using a 2" flat brush and with the paper flat once again, I then pulled the colors away from the channels and toward the paper edges until the entire paper was covered with paint.

This process was repeated with other colors for numerous layers. Each layer also was then treated with various methods to create the illusion of texture: rubbing alcohol was sprayed on the paint before it dried, the damp paint was scraped and scratched with assorted tools, plastic wrap or wax paper was pressed on and removed from damp paint in certain areas; and sometimes the paper was flipped over onto another smooth surface to create other textural effects.

After about 7 layers, I propped the painting up on my mantel for a while to see if it evoked any particular subject or idea before completion. Eventually I felt that the surface resembled a rock wall. I felt it needed more variety to enhance the design.

I then applied acrylic medium and sprinkled sand on an area in the shape of a waterfall.

When this was dry, I diluted white gesso with water and poured this over the sandy area, wiping off any gesso that strayed too far from the edges of the sand.

My final step was to use my hand cut spiral stamps. I applied acrylic paint to the stamps and printed them in 3 areas to finish the prehistoric wall effect. I then added a few extra strokes to each spiral to duplicate the shapes found in early ancestral Pueblo rock art.

Rock Art
By Tis Huberth
Mixed Media/Acrylic
13" x 18"

Robert Kevin

I began this painting with a 36" x 24" stretched canvas. I have been painting for over 40 years and this is the style of work I have been doing lately. I started with black acrylic paint on a clean canvas. I left a strip on the left side of the canvas without paint so I could add bright colors to the canvas later.

After the black paint dried I mixed shades of yellows and cream and applied this over the black paint sporadically. Then I mixed shades of gold and applied it over some of the yellow and black with a painting knife.

Next, I brought in the colors of red and orange and applied them to the area that had been left blank. Following this, blues and greens were added to the picture. A painting knife was used to apply most of the shades of color.

I came back in with black acrylic paint and gave definition where I felt it was needed. My last step was to seal the painting with a varnish to make the colors stand out more vividly.

I have painted realistic pictures of clipper ships, portraits and landscapes but I love the freedom of abstract work. It still takes as much, if not more ability, to do abstract work because it's all imagination.

Vail of Color
By Robert Kevin
Acrylic on Canvas
36" x 24" x 1 3/8" solid wood frame, 7-oz 100% natural cotton duck, back-stapled

Judy Kramer

The photographic process is unique in that an image can be captured in a short period of time...often fractions of a second or less...but what determines the image is a more complex subject. Choice of equipment can be tantamount to the success of the image...optics, lenses and sophistication of the camera can play a role. In the long run though, a successful photograph can be taken with any level of photographic equipment, from a pinhole camera to a super sophisticated digital camera or large format camera. More importantly, the photographer must be comfortable with the workings of their camera.

Recognition of a good subject is often a process of exploration of the subject. The photographer's positioning to the subject can make or break a successful image. A good photographer will capture the essence of the subject by close cropping as well.

State of mind on the day of the capture of the photograph can make or break the success of an image. Sometimes I have to zone out interfering thoughts, surrounding elements and preconceived visual illusions, and become "one" with the location where I'm shooting.

Perhaps the most important element to a successful photograph is light and the recognition of its importance to the subject.

I present this information so that the viewer of my photographs will better understand my process. Although I enjoy photographing many subjects, I am often intrigued by the unique vision of close-ups of objects. My favorite place to search for these visions is an auto junkyard not far from my home. With hundreds of cars to choose from...many in horrific states of rust, deterioration and destruction...I carefully search for visions that intrigue me. Sometimes broken glass performs wonderful illusions and reflections. At other times, scarring of the paint, fenders or mechanical workings of the cars provides exciting visions.

This photograph is a view into the exposed inner elements of the car's construction. Rust, bent metal and fibrous elements display smooth and rough textures. The coppery color combines with the deep dark metal spaces to give form to the image. Each area of the image draws interest to the next...encouraging the viewer to form an opinion or confirmation of what the subject really is....though the "what" is not as important as the vision and emotion it evokes.

I used the Nikon DSLR D80 camera on this shoot. My tripod is my second and probably most important tool. It helps me to slow down and make careful and successful compositions. My 28-105 mm lens was set at 75 mm. My ISO was at 400, my aperture at f11 for good depth of field and I shot at 1/25 second. The light at this location is often very strong; however exciting images are often in elusive places on the cars and trucks, and consequently shadows, depth in color and great texture show up in the images.

In the processing and printing of this image, I used no digital manipulations or creative tools...the image was printed as I recorded it...through my camera's eye. The print was made on an Epson Stylus PHOTO 2200 printer.

Sunrise-Sunset by Judy Kramer. Color Photograph. 12" x 17"

Witha Lacuesta

My inspiration for a new abstract painting might be a piece of music, a dance movement or just a word. This inspiration is the genesis of penciled shapes and patterns. After making several thumbnail sketches I do a large drawing the size of my future painting as I work out the design, including different components of the thumbnails. Evolving to a satisfactory design might take several days after which I will transfer this drawing to the watercolor paper, usually 140 lb or 300 lb Arches bright white watercolor paper. I mark areas to be kept white and those I plan to use for a particular color. Then I begin the actual painting process.

I mostly use watercolors from Schmincke, Daniel Smith, and Winsor & Newton because they provide the clearest and cleanest colors for the intended outcome. I always test the properties of any new color I add to my palette. I first test it singularly and then observe its reaction to the other pertinent colors on my palette. I start my first color application with a thin wash of dominating color saving the whites in areas where I have not yet made a decision. I let this wash dry completely and reevaluate my composition in this first phase so that I will have a chance to make changes if needed. From here on I just let myself be guided by the colors, pigments and their reaction to each other. The movement and mood created is very important in my abstracts because they must support my theme. I may let certain painted areas dry completely while in other sections I might continue to add different pigments and observe their reaction. I prefer to use many of the Daniel Smith gemstone pigments because of their tendency and variation to granulate. My darkest values are all my own mixtures in variations of concentrated phthalo blue, phthalo green, alizarin crimson, prussian blue and sometimes raw umber, or even sepia. Adding or changing shapes as the work develops contributes to its spontaneity despite the original drawing. By now the original design has been considerably changed and new shapes have emerged. I continue this process until the painting feels right.

Occasionally, I will spray or splash some discrete areas on the painting to pull that section together. My abstracts all have a focus. Sometimes it is a selected area with primary colors or where there is a more intense value. All during this process I take many breaks to reflect on the work. Often, weeks pass before I feel inspired to continue, and as a result, I often making dramatic changes in the overall composition. The end result is a painting with as many as 30 to 40 glazes in parts and a composition that conveys positive feelings. The subtle areas which develop during the painting process will give the viewer the opportunity to always discover new aspects, shapes, color, feelings, and energy in the painting.

Dance Bolero by Witha Lacuesta. Watercolor. 28" x 20"

Witha Lacuesta

My inspiration for a new abstract painting might be a piece of music, a dance movement or just a word. This inspiration is the genesis of penciled shapes and patterns. After making several thumbnail sketches I do a large drawing the size of my future painting as I work out the design, including different components of the thumbnails. Evolving to a satisfactory design might take several days after which I will transfer this drawing to the watercolor paper, usually 140 lb or 300 lb Arches bright white watercolor paper. I mark areas to be kept white and those I plan to use for a particular color. Then I begin the actual painting process.

I mostly use watercolors from Schmincke, Daniel Smith, and Winsor & Newton because they provide the clearest and cleanest colors for the intended outcome. I always test the properties of any new color I add to my palette. I first test it singularly and then observe its reaction to the other pertinent colors on my palette. I start my first color application with a thin wash of dominating color saving the whites in areas where I have not yet made a decision. I let this wash dry completely and reevaluate my composition in this first phase so that I will have a chance to make changes if needed. From here on I just let myself be guided by the colors, pigments and their reaction to each other. The movement and mood created is very important in my abstracts because they must support my theme. I may let certain painted areas dry completely while in other sections I might continue to add different pigments and observe their reaction. I prefer to use many of the Daniel Smith gemstone pigments because of their tendency and variation to granulate. My darkest values are all my own mixtures in variations of concentrated phthalo blue, phthalo green, alizarin crimson, prussian blue and sometimes raw umber, or even sepia. Adding or changing shapes as the work develops contributes to its spontaneity despite the original drawing. By now the original design has been considerably changed and new shapes have emerged. I continue this process until the painting feels right.

Occasionally, I will spray or splash some discrete areas on the painting to pull that section together. My abstracts all have a focus. Sometimes it is a selected area with primary colors or where there is a more intense value. All during this process I take many breaks to reflect on the work. Often, weeks pass before I feel inspired to continue, and as a result, I often making dramatic changes in the overall composition. The end result is a painting with as many as 30 to 40 glazes in parts and a composition that conveys positive feelings. The subtle areas which develop during the painting process will give the viewer the opportunity to always discover new aspects, shapes, color, feelings, and energy in the painting.

Dance IX by Witha Lacuesta. Watercolor. 28" x 20"

David J. Leblanc

The cover for Action Comics No. 48 explodes with the eye-catching image of a confident Superman streaking upward and punching a Japanese Zero in mid flight, before it can begin its dive toward the American naval fleet below. This dramatic portrait captures the spirit and intent of the Action Abstraction series. I knew instantly when I saw the cover in The Golden Age of Superman: The Greatest Covers of Action Comics from the '30s to the '50s, a book which is the "bible" inspiring this growing collection of work. When first envisioning the Action Abstraction series I saw a distinct parallel to the work of Jean Michel Basquiat: primitive figures masquerading as superheroes wading through waves of repeated sound effects, emotionally charged words and phrases and significant pop icons. However, I feared that my work in the end would only be derivative if I took that course, so I didn't.

Primarily, my objective is to take two entirely different approaches to art, storytelling and abstraction, and merge them, transforming them into something entirely new, something unique. Comic books from the 1930's and 1940's have a very narrow palette of primary colors due to the limitations of the printing press at that time. I stay faithful to this palette. However, I use acrylic latex enamel as my medium. The enamel is flexible enough that I can use it to create expressive, abstract compositions with fluid and bold brush strokes, as well as controlled drips and splashes.

The first area I focus on in my Action Abstraction paintings is the top third of the canvas. This painting was no different. This section on the original cover is devoted to the title banner. I use blue painter's tape to mask off the banner and the lettering. Creating these hard edges generates a contrast to the overlaying looser strokes and contributes to the layering and depth of the painting. I also collage with newspapers and comic book pages which I partially paint over to build depth.

Next, I build up the larger bottom section which represents the Pacific Ocean. For the section to resemble water, I mix washes to resemble watercolor paint and then build up the depth a bit by adding paint little by little, allowing the paint to drip freely. The goal is to maintain the wash's water look, and yet make sure the ocean could stand up to the brash, opaque colors of the thickly painted banner at the top of the picture.

Now, finally, I connect the two portions. By establishing the focal point, the whole piece came together. The two main elements which make up the focus of the painting need to come into play: the plane and the hero! After experimenting with the brown from the cover, it is obvious that a starker contrast is needed to set off not only the banner and the ocean, but the centered blue, yellow, and red figure representing Superman. The plane would be black. This would bring the composition to life, but splinter it as well. I quickly decided to add more red, yellow, black, and orange strokes bursting above and through the streaking hero. This builds further depth into the painting. But there is still something missing... the space between the hero and the ocean needs something. I see the yellow and orange crescent shape of the impact of the hero and plane, and reflect that shape again as a "c" in the classic Action Comics title font.

Action Abstraction No. 6: "Battle Over the Pacific" by David J. Leblanc
Acrylic enamel and collage on canvas. 60" x 44"

Three years... Action Abstraction No. 12: "Powerless...!" took three years to complete! During 2008-2010 this painting would go up and down on old used paint cans that were substituted for an easel, until the final brush stroke was laid down. The significance of this piece has been its transitional nature. The No. 12 canvas was the first new painting I started after hanging my first solo exhibition at the co-operative gallery in which I am still a member. Action Abstraction No. 12 illuminated for me how difficult it can be for an artist to grow after a successful show. I had to work over a period of months to challenge myself to improve, and not allow my work to stagnate.

Immediately, I created a new challenge by the comic book cover that I chose. The cover forced me to change my palette. Up to this point I had been flipping through The Golden Age of Superman: The Greatest Covers of Action Comics from the '30s to the '50s for the inspiration for my series of paintings. Until now, the images were thoroughly composed of rarely mixed primary colors. For No. 12, my inspiration came from a site on the internet called Cover Browser. I wanted to expand my search for "action" covers that exemplified the iconic notion of Superman. I decided the cover of Action Comics #280, portraying a gigantic Brainiac entrapping the shrunken Superman, Lois Lane, Jimmy Olsen and Perry White, dramatically depicted the determination and courage of the Man of Steel. This was the first cover that I chose that was of a different era in the history of Superman. The palette used more pastel tones, more pinks, lime sherbet greens, and large open areas of white. Thus, Action Abstraction No. 12 was a clear departure from prior paintings in this series.

The actual painting process began with the entire surface of the 72" x 56" canvas being collaged with torn and cut pieces of various sizes from comic books, Rolling Stone magazine, advertisements, etc. Collaging the entire surface allowed me to craft a hidden story below the surface. The paper was arranged to fairly reflect the colors and lines from the original cover. The collage needed to be visible in places as foundation or as an overlayer. The application of collage was a vital part of the painting process, and I found that Golden soft gel medium applied with a Liquitex large No. 13 palette knife allowed quick application for the best effect. Another thin layer of the soft gel was later spread over the exposed sections of collage for archival purposes.

I tended to masked off large sections of the painting at this point with blue painter's tape, so the picture plane was easier to manage. An example was the large horizontal area at the top of the canvas (title banner), thin lines for banner trim, and pieces of the lettering that composed the title. The hard edges of Brainiac's shoulders and head, and the tabletop, were also used to stabilize the composition.

Acrylic latex enamel was brushed on with a variety of artist's brushes and house-painting brushes. The nature of this water-based medium allowed me to use a wide range of saturations from wash to opaque. The effect enabled the paint to drip or be splashed or employed in bold strokes, but still be largely controlled and layered. A balanced composition was generated with depth and texture with many elements and came together to form something new and unique.

Action Abstraction No. 12: "Powerless...!" by David J. Leblanc
Acrylic enamel and collage on canvas. 72" x 56"

Jeffery Levin

Rainbow seaweed in relief highlights the shallow ocean, swirling around luminous nautilus shells (finished in pearlescent rainbows). Two of these are reliefs. The fish at the left (scales are in relief) swims forward leaving the shadows of where it had been. All is set against a ground of deep blue and white blended swirls. All paint is Winsor & Newton oil. All reliefs are comprised of Golden extra heavy gel medium.

At the Seashore
By Jeffery Levin
Oil

A drop in the left corner seeps smaller droplets, then dividing into the separate colors each signifying a different aspect of our physical and emotional plane. They come together at the base of the fall; rising to spill over at the top, descending in drops to the multi-colored pool with the large colorful SIGNATURE CANDY KISS bobbing on the surface; the pool, brimming over, overflows in a sheet of multi-colored liquid separating into descending droplets.

This painting contains a number reliefs, beginning with the drop in the left corner and the drops sweating from the surface. As the flowing liquid descends it forms other reliefs moving through the color, forming small vignettes...the red forms 3D hearts... the orange a cobra...the yellow a cyclone... the green pure design... the blue the ocean and violet geometric blocks.

As the fall breaks , I've embedded toothpicks to represent the liquid shredding... breaking again into pastel drops, growing larger and more intense in color as they reach the single large CANDY KISS in the center of the pond. At the leading edge of the pond the liquid brims over, thus spilling over in sheets...as it descends it again breaks off into rainbow relief drops. All this is set on an ultramarine deep blue ground. All paint is Winsor & Newton oil and all reliefs are comprised of Golden extra heavy gel molding paste.

MacLevin

Signature
By Jeffery Levin
Oil

Monica Linville

Recent years have found me focusing on using a spontaneous underpainting as my guide throughout the process of each painting I do. I believe this is the painting's heart…it's pulse….it's soul. I will think of something, look at something, listen to something or all of the above and just let myself react to it with brushwork and color. I then set it up to dry and live with it for a few days in my studio, studying the dynamics created during this phase of the work. Since I call this technique "instinctual painting", describing the specifics of how it is done is difficult.

In this painting I saw a modern dance performance that captured my imagination. There were three dancers, all dressed in long, flowing skirts. They danced together as a single unit throughout the entire performance, each movement an exact reflection of the other dancers. At one point they appeared to be suspended in air, with their heads, arms and bended legs thrust backwards, their chests thrust forward leading the way. I found the energy, grace and strength that they captured even while throwing their bodies in opposing directions to be amazingly powerful. In addition, they moved together so closely that their skirts flowed together as if one, adding to the illusion of these three separate individuals being a single unit, moving together through space in a single moment.

So much of what I paint has to do with our shared energy and our connections to each other and the universe. This performance seemed to reflect that philosophy. When I approached this painting it was the memory of this dance, the movements, the power, the combined energy that I attempted to capture. I work on Winsor & Newton Deep Edged Artist Canvas with a variety of oil paint brands and colors. I am not brand loyal, only color loyal. As all brands don't make all the colors I need, my palette is made up of various and sundry brands of paint, made fluid by the addition of mineral spirits. I use no other mediums or additives. I then simply stood back from the canvas and tried to recreate the dynamics of this dance with sweeping brushstrokes and thrown paint. I let the paint do what it wanted to do, working with the canvas upright on an easel so that the paint would move without my pushing it.

I am not socially or politically motivated in my painting. I believe that my job as an artist is to give you a place of refuge; a place where your mind has room to move; a place where it's ok to have emotional responses. The key word here is place because in my mind by definition a place is somewhere you go to. With this being the case, it is then necessary for me to GIVE you some place to go and a reason to go there. This dictates my color selection, the way I use light and the way I reinforce movement.

I want my paintings to embrace you and I want our relationship as artist and viewer to be an intimate one. For this reason I use the intensity of warm, harmonious colors to pull you in to the piece and backlighting to encourage you to explore. Once the dynamics of the painting's movement are established in the underpainting process, every single decision I make from that point on becomes about honoring those dynamics. Without your knowing it, your eye is being led along my initial brushstrokes by using color, value and texture. I leave part of the underpainting exposed because I find the contrast of transparent layers against opaque to be exciting as well. By creating a path of "contrasts", whether they are warm/cool, light/dark, texture/smooth, transparent/opaque or complementary colors, your eye MOVES. Balancing these elements binds the painting together so that, like the dancers, the painting and the viewer are a single unit thrusting forward through space.

3 Sisters
By Monica Linville
Oil on Canvas
24" x 30"

Carol A. McIntyre

We artists can be as surprised by what inspires us as non-artists. This piece was inspired by a new paintbrush with an odd shape. I had just found a small feather-shaped brush with soft bristles in the art store. When I got back to the studio, I began playing around with the different shapes I could create with paint. I did this on a scrap piece of canvas. I kept making these soft, round amoeba-like shapes and decided that I had to start a painting!

Using a Masonite board, I applied 3 layers of gesso with a large 8" palette knife, letting each layer dry before applying the next. My palette knife technique is very light; hence, the texture is subtle. My first layer of paint was rolled on with a brayer. I almost always start with the very light colors of white, yellow and orange. These light colors help to create the depth in the painting that I ultimately want.

My color palette, which I determine before I begin every painting, consisted of browns, oranges and turquoise. Staying within a certain color palette provides color harmony which is something I strive for in all of my work.

This painting began as a horizontal painting, but as I progressed I kept moving the board on my easel and decided that the design was working best as a vertical. The circular shapes were painted to create a sense of movement and rhythm. More attention and detail were given to the two bright areas of the painting. As I painted, I discovered that my new brush allowed me to paint the wavy lines. These lines were really fun and I had to make sure to stop before they took over the painting! I loved the feeling of netting that started to emerge.

For the finishing touches, I added lighter values of paint to give the amoeba-like shapes some dimension and to draw the eye of the viewer around the painting. I also used the color opposites of orange and blue to do the same. The title for this painting was a challenge because people who visited my studio saw so many different things. I wanted the title to convey the feeling of the painting, so I decided on "Floating Winds." Some viewers say that it reminds them of a peacock, others see the sea. What comes to mind for you?

Floating Winds
By Carol A. McIntyre
Oil
18" x 21"

Because I do not like the mechanical texture of canvas, I prepare every painting surface with two to three layers of gesso. Gesso, a creamy substance much like sour cream, dries quickly and is often the material artists use to prepare their canvases or boards. I use a large 8" palette knife to apply the gesso to create an organic texture. Each layer must dry before the next is applied.

Before beginning piece I presented myself with a couple of artistic challenges: 1) the predominant colors would be from the red family; and 2) I wanted to combine organic shapes with geometric shapes.

All of my abstracts are created with the intent to communicate color harmony and intrigue. I also strive to create a sense of depth to draw the viewer into the work.

My first layer of paint included the yellows and lime greens, as well as the geometric lines/shapes you see around the edges of the painting – they look like boxes. You can notice that these reds are a combination of cool and warm reds. I do not use tape to make these straight lines. Instead I draw them lightly with a watercolor pencil using a plastic ruler and paint the lines free-hand with a flat brush. Fortunately I have a very steady hand!

Before I begin a painting, I determine my color palette. This allows me freedom within the limits I define. For this painting I chose the family of reds along with grays, whites and browns. The lime green is a color opposite of red and I knew I wanted to use it sparingly and to bring attention to certain areas.

With a palette knife, I next started applying varied light and dark grays, making certain that I preserved some areas of the light colors I had already painted. This is the stage of the painting where I spend time just looking at the shapes and colors to find areas I want to keep and accentuate. I knew I needed to add some dark reds and darker browns after the grays to bring in some contrast. Note: I never paint with black. With the palette knife edge, I started creating the curved lines and could begin to see vertebrae emerging.

Various shapes were then created and connected using brushes. I altered between my palette knives and my brushes. The layers give depth to the painting, which is important to encourage the viewer to spend more time within the painting. Eventually, the figures become more evident and appear to be dancing.

The horizontal stripes and small boxes were added for balance in my design. They also contribute to the tension within the painting – between the smooth and textured areas, and the organic with the geometric shapes. Do you see dancing or do you see something else?

Tango From the Inside Out
By Carol A. McIntyre
Oil on wapped canvas
24" x 36"

John McLaughlin

I begin my paintings with an ivory acrylic painted background on canvas. Then I add and subtracting paint and drawings in layers over a period of days and weeks, sometimes months. Using graphite pencil, crayon and oil paint stick, I create abstract marks and scribbles along with the more representational drawn forms of nature and animals. In this way I create a collage-type landscape in a combined expressionistic and traditional style. I continue this investigation into the possibilities of the accidental along with the more deliberate forms and lines, mimicking nature and the objects of the manmade world. The labors are personal, but also come from a place of acutely studied history of art, design and music.

Similar to a musical composition, I slowly created this painting by building on and modifying motifs applied in previous layers. I embraced improvisational gestures and incidents, allowing some of the previous marks to show in a palimpsest manner. Among this rich layering are fits and starts of lines, doodles and sketches. This action occurs in so many layers that some images are barely perceivable, giving insight to my thought process and my own searching for more clues. On the top layer are hazy spaces of the paintings hard-lined, organic shapes of color and line drawings that conjure a quirky aggregate of the ancient, scientific and industrial hieroglyphs. I strive to attain a steady, engrossing read that gradually reveals the history and resolve of the painted picture.

My work involves my subconscious. I may start with a particular idea of color and form but I let my meditative mind take over and guide me in my drawings and mark-making. Many times I don't recognize what I made, so it remains a constant discovery and intrigue for me.

Between the Lines by John McLaughlin Mixed media. 24" x 30" x 1.5"

I begin my paintings with an ivory acrylic painted background on canvas. Then I add and subtracting paint and drawings in layers over a period of days and weeks, sometimes months. Using graphite pencil, crayon and oil paint stick, I create abstract marks and scribbles along with the more representational drawn forms of nature and animals. In this way I create a collage-type landscape in a combined expressionistic and traditional style. I continue this investigation into the possibilities of the accidental along with the more deliberate forms and lines, mimicking nature and the objects of the man-made world. The labors are personal, but also come from a place of acutely studied history of art, design and music.

Similar to a musical composition, I slowly created this painting by building on and modifying motifs applied in previous layers. I embraced improvisational gestures and incidents, allowing some of the previous marks to show in a palimpsest manner. Among this rich layering are fits and starts of lines, doodles and sketches. This action occurs in so many layers that some images are barely perceivable, giving insight to my thought process and my own searching for more clues. On the top layer are hazy spaces of the paintings hard-lined, organic shapes of color and line drawings that conjure a quirky aggregate of the ancient, scientific and industrial hieroglyphs. I strive to attain a steady, engrossing read that gradually reveals the history and resolve of the painted picture.

My work involves my subconscious. I may start with a particular idea of color and form but I let my meditative mind take over and guide me in my drawings and mark-making. Many times I don't recognize what I made, so it remains a constant discovery and intrigue for me.

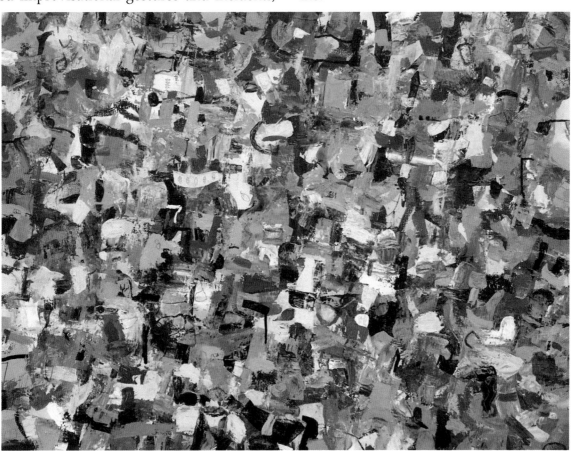

Johnny Got A Bam by John McLaughlin
Mixed media on Blick premium canvas. 30" x 40" x 1.5"

Catherine Mein, ISAP

I began this painting using black gesso, a brayer and heavy duty aluminum foil. Spreading the black gesso on the foil with the brayer, I waited a bit until the paint lost some of its sheen. I turned the foil over onto a piece of 140 lb. Arches cold press watercolor paper and gently laid the foil down where I wanted the paint to go, knowing I wanted to use a bridge design format. Using the back of a brush as a writing tool, I drew the shape of a figure on the foil, adding various expressive lines. I removed the foil and let the piece dry. Then, using Caran D'Ache Neocolor II water soluble crayons, I began to make marks within the figure using purple, blue, green, and white. I also added more black gesso directly to the watercolor paper and used a gold magic marker to help define the shape and bring out the bright colors of the crayons.

I then painted an assortment of white tissue papers with acrylic paint using a variety of colors, stamps, and brushed calligraphy marks. After they dried, these tissue papers were torn into desired shapes and then applied to the watercolor paper as collage, and glued with a mix of equal parts gloss medium, matte medium and water.

For the night sky, I initially painted black gesso on the front and then the back of the white tissue paper, allowing each side to dry. For the second layer of this paper, I stamped a square shape with gold paint. After it dried, I then splattered white titanium paint onto the surface with a brush. A fourth layer consisted of a star stamp brushed with copper paint and touched with pink in the center.

For the blue clouds, I used variations of cerulean blue and titanium white acrylic paint with the tissue paper. Other painted papers included a toned-down green and one with a touch of lavender. A zigzag white accent was added to a black painted paper. For a final touch, I stamped a "G" with white titanium paint. I used the crayons to create softer edges on some parts of the painting, creating a stitch pattern as something that might be found on a quilt, to symbolize the tapestry of life.

This painting is very near and dear to my heart. Painted at a time of challenges in life, it is a symbol of coming out of the rain, standing firm in stillness, and seeing the stars of divine love as we embrace with gratitude the life that we are given.

Celestial Goddess
By Catherine Mein, ISAP
Mixed Media and Collage
27" x 21"

Transformation in Time III expresses the union of spirit and matter coming together and being transformed into something beautiful. There is an old world feel to the painting, accomplished by using golden orange and grey black tones. This creates an inner glow reflecting ancient wisdom. A more modern perspective is created by the half circle and grid system design undergirding the painting. Through the use of abstraction, not all is revealed and the element of mystery is enhanced. This painting brings the ancient and modern together as an expression of our spirituality.

I started with 300 lb. Arches cold press watercolor paper. Painted tissue papers were then created separately by applying paint in patterns, sometimes with the help of stamps, stencils, and calligraphy marks. To do this, I used Golden fluid acrylic paints that included black, grey, quinacridone nickel azo gold, yellow, copper, cerulean blue, and titanium white as well as Liquitex baltic blue. These papers were then torn or cut into desired shapes and collaged onto the paper, using a mixture of equal parts gloss medium, matte medium and water. Other papers were created by gluing newspapers to the art tissue paper and then painting over it.

In another section, a stained coffee filter was accented with Caran D'Ache Neocolor II water soluble crayons and applied. A few Oriental papers and old book pages were also added for effect. More details were then applied over areas of the piece to help bring this painting together as a cohesive whole.

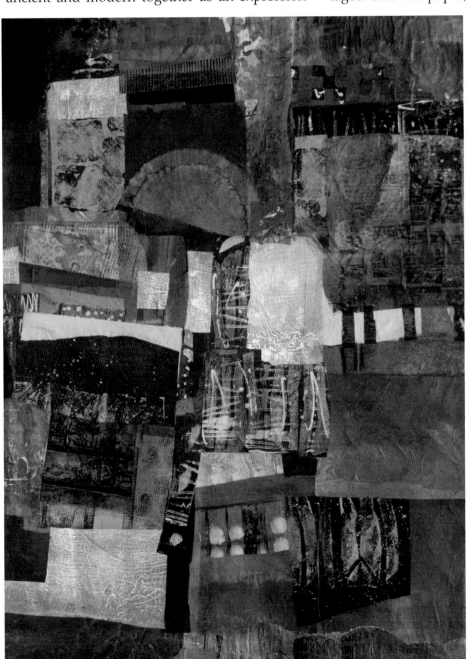

Transformation in Time III by Catherine Mein, ISAP Mixed Media and Collage. 30" x 38"

Julie Elizabeth Mignard

My canvas was custom-made to my specifications by the Efron Gonzales Art Center in Ajijic, Jalisco, Mexico. They have been stretching my canvases since 2002. It is cotton canvas gessoed with white acrylic. I added two coats of gesso in a light green. I begin with a background texture. The canvas lies in a horizontal position across four milk crates on the studio floor. Using white liquid enamel exterior rustproof paint I sling out long strings in a random pattern while walking around the canvas. This must dry for several days until it is hard and shiny.

During warm dry weather I begin the main body of the painting. I use fast-drying liquid enamels in premixed colors. I select my colors, in this case every shade I have of blue and green, plus ivory, red-orange, and metallic gold, and open all the small cans. I stir them all up using plastic picnic spoons. I must be careful not to let the spoons rest too long in the paint or they dissolve. When all is ready, I ask my adult self to mentally go get in the swimming pool and I turn my artist child loose.

Beginning with the ivory, and progressing from lightest to the very dark blue and ending with the metallic gold, I sling, drip, pour and splash a total of about 2 liters of enamel paint onto the canvas. My main painting tool for this size canvas is a long-handled rubber squeegee of the size used by commercial window washers. Walking around the canvas, I pull the various colors together until the entire surface is covered and paint is running over the edges. On this painting, I felt that the upper right quadrant was becoming too homogenized so I pressed the rubber blade firmly and dumped about half a liter of paint onto the floor revealing the underlying lines of the original pour. However, this still left a thin covering of the bland mixed color, so I poured a small amount of solvent directly onto the offending spot.

Much to my surprise, the solvent penetrated easily into the cotton canvas and wicked throughout the entire piece, lightening every place where the paint was thin, to very good effect. When I was satisfied that the composition was finished, I brought my adult self back to work, cleaned up the edges of the canvas to make a studio wrap finish and checked to see if everything else was satisfactory.

By the next day, the surface was firm and shiny, but there was a good deal of unhardened paint under the surface. This is when the best details of the painting are formed. As the underlying paint dries, the separate colors begin to appear in fine lines, circles, and swirls. Also, the earlier dried surface may wrinkle extensively as the puddles under them shrink. These aspects I control, first by tilting the canvas, and after a few days, placing it in a vertical position on an easel to allow gravity to finish the special effects I like so well. I turn it perhaps hourly, sometimes daily until it has completely hardened and is ready to hang.

By this time, it has acquired a name and I have chosen which way the painting is to hang, in this case horizontally, and have the wire placed on the back. I write the name of the painting, the date, and my full signature on the back of the stretcher where the canvas is still white along the top edge. I sign the front with my signature initials, and all is finished.

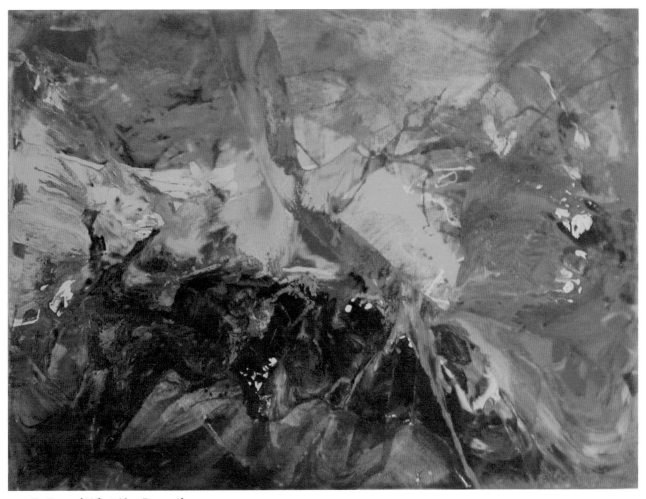

To Reveal What Lies Beneath
By Julie Elizabeth Mignard
Oil on canvas
48" x 66" x 3"

Joye Moon

Always wanting to depict light, shadow and movement in any subject matter I paint, I envisioned ribbons of color floating in front of a diverse background, yet co-mingling with some of the background as well. I also wanted to take full advantage of the value scale by using the white of the paper as strong connecting shapes, and using black to detail final shapes I wanted to feature.

I started with a few basic lines of movement drawn onto Richeson 140 lb. cold press watercolor paper. I did not use any masking fluid to save the white of the paper; I just painted large wet on wet washes of color around the white shapes I wanted to save. More white was showing at the beginning of the painting but it eventually got filled in with different shapes of color and textures. I implemented many different methods to create a diverse background such as lifting color away while the paint was still damp to create lines of movement. I also applied a loaded brush of water onto damp paint to separate a solid color area, which resulted in an irregular edged area that was welcome because of all the hard edges. Table salt was sprinkled onto wet paint to create a random texture. I basically used a variety of warm colors in the background area such as quinacridone gold, burnt sienna and quinacridone coral, plus various reds, oranges and browns to create interesting brown tones.

While the background was developing, I started to paint the floating ribbons of color. Every time one ribbon intersected lines from another ribbon, it gave me the opportunity to switch the color or use another value of that same color or disregard it completely if a long passage of color was needed for the understanding of the viewer. Since I used a warm color palette for the background, I needed to add several cool color notes for interest. Various purples, magenta, greens and blues were used to contrast with the background.

Finishing touches: Bottles of color were strategically sprayed onto the surface to move areas farther back and to create interesting textures. I positioned masking tape on the paper surface, cut an interesting shape with an X-Acto knife, and sprayed paint either inside the masking tape or along the edge of the tape. I mixed paint to create a dark color to be used as my black or darkest dark. I then strategically painted these dark shapes alongside and behind background areas to add depth and define the ribbons of color.

A special thank you to the owners of this painting, Craig and Deb Shaning, of Oconomowoc, WI, for consenting to have this image published in this book.

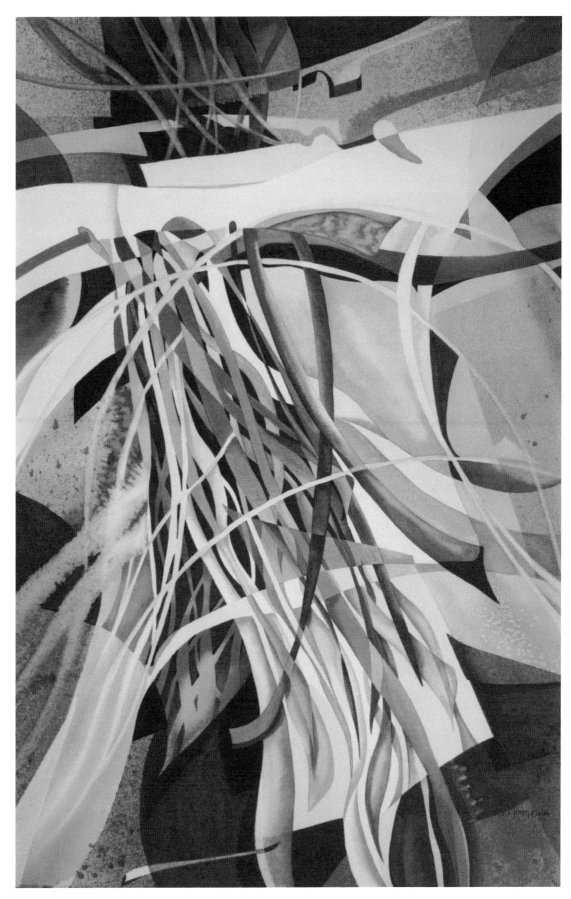

A Breezy
Day by Joye
Moon.
Watercolor.
15" x 22"

This painting was created by using transparent watercolor, black acrylic and collage. Incorporating a figure into an abstract format can be great fun! Inspired by flamenco dancers while in Barcelona, Spain, my main concern was to try to capture their graceful movements while dancing.

Starting with a basic line drawing onto Richeson 140 lb. cold press watercolor paper, I began to break up the background with washes of watercolor while the white of the paper was left for the dancer. Since her movement was most important to the composition, I broke up the background to enhance the illusion of movement by painting many levels of color in the arm areas and around her head. I sprayed color from small bottles to create textures and to break up the space into an interesting design in the background.

I continued to vary the color shapes inside the figure to enhance the illusion of movement. Since I used a warm color palette for the background, I decided to use subtle cool colors for the main figure. A variety of greens and blues helped separate the figure from the background color. Black acrylic was positioned in key areas to help separate the dancer from the background and move her forward in the composition. Solid black was used as well as scraping some of the acrylic away and I also gently lifted some of the black with a brush to vary the value.

Finishing touches: Colorful magazine papers were cut and glued into position. The blue ribbons of her dress and the orange bits floating in the background are the collage pieces. They also help enhance the moving quality of the dancer. I needed to lose some color in her dress and in the background so I used masking tape to create an open shape, so I could swipe away color using a damp Mr. Clean Magic Eraser.

I am very pleased with the completed painting. The movement I wanted to capture was achieved and Dancing Girl reminds me of the graceful flamenco dancers of Spain.

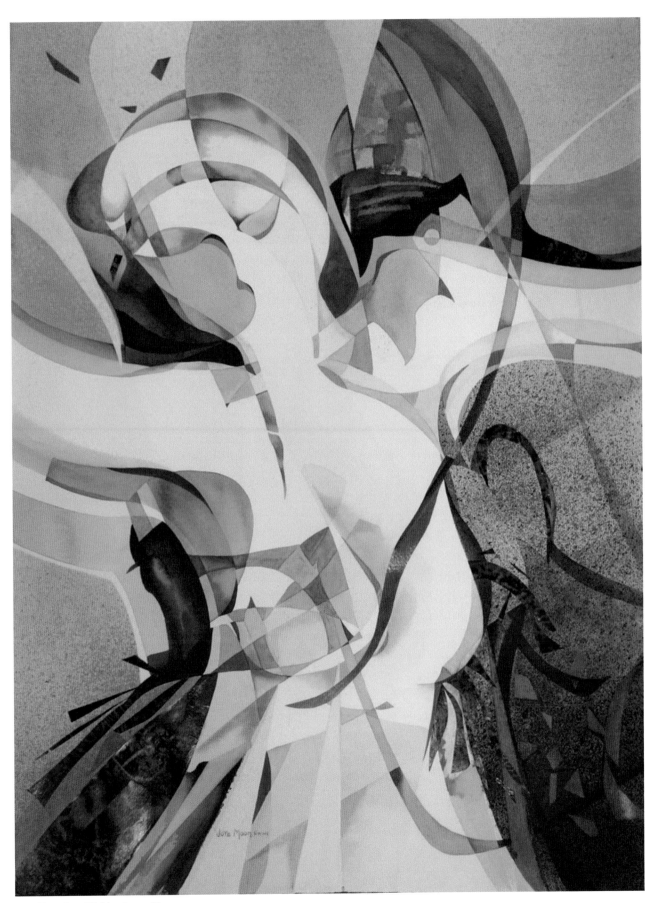

Dancing Girl by Joye Moon
Watercolor, Acrylic and Collage. 22" x 30"

Kathleen Mooney, NWS, ISEA-NF

I place a large tarp on my work table. I work flat because my techniques explore the freedom and flow of liquids. It can be very messy. Then, I unwrap a 36 x 36 x 2.5 inch "The Edge" canvas and place it on the tarp.

Paint around the edges on the top part of the canvas and all of the sides while leaving the center area free of paint. I used Behr paint, "Black Suede", and let it partially dry -- still damp, but with a skin forming on it. It helps speed the drying by having an overhead fan running in your paint work area.

Then, I freely pour Golden Artist Colors Fluid Acrylic in Cobalt Turquois and Nickel Azo Yellow in a loose "plaid" over the top of the canvas. Using a drywall / wallpaper trowel scrape through the Golden paint and through the Behr paint so that the Cobalt Turquois and Nickel Azo Yellow push into the canvas in the center. This takes some force and leaves an uneven and ruined looking surface with some of the original white canvas peeking through. The Cobalt Turquois and Nickel Azo Yellow blend and form a verdigris copper color in some areas. As you scrape, transfer the excess paint to a plastic container or paper plate so you can use these colors later. Keep the trowel clean. Practice this technique in advance on scrap paper or canvas. The more you practice, the less likely you are to end up with mud.

Take clear clean water and splash it onto the paint on the canvas. Let it stand for 3-5 minutes and then blot firmly down and directly back up with a small pad of paper towels. This lifts paint from areas and reveals layers of paint -- in some cases all the way down to the canvas.

While the paint is still damp on the canvas, I select several of my hand cut "Signs and Symbols" stamp bocks. These are cut with a Speedball carving tool set using Easy Cut blocks. I use these stamp blocks in countless art projects. Most are cut from 6" by 12" blocks. I have at least 100 of these blocks and I store them in flat file drawers and plastic bins.

Using a 1 ½" house painting brush loosely paint some of the selected blocks with the messy paint mix that was pulled off of the canvas. Stamp the blocks on the canvas pushing the paint into and through the paint layers and deep into the canvas. If you need to change colors on the stamps let the blocks air dry or print them off on newspaper until they are dry. Change to Golden Artist Colors Fluid Acrylic Red Oxide and repeat the stamping. My goal is to add "lines" of stamped signs and symbols to lead the eye around the painting and to form a border on the lightest Cobalt Turquois area. Change to DecoArt Copper acrylic paint and repeat in fewer areas. In some areas I am offsetting and printing a second color near the first.

The stamping can be controlled by lightly touching the paint to the surface or by firmly pressing into the canvas. Each variation of pressure adds more interest. Selecting a ½" round oil painting brush selectively paint some light highlights and some copper on and near the stamped images. Let the painting dry and then evaluate it.

Ether(eal)
By Kathleen Mooney, NWS, ISEA-NF
Acrylic on Canvas
36" x 36"

I place a large tarp on my work table. I work flat because my techniques explore the freedom and flow of liquids. It can be very messy. Then, I unwrap a 26 x 20 inch acrylic primed canvas and place it on the tarp.

Paint around the edges and on the top part of the canvas with DecoArt acrylic paint in a Turquois color. Let it partially dry -- still damp, but with a skin forming on it. It helps speed the drying by having an overhead fan running in your paint work area. Press white Pacon Art Tissue paper into the paint, molding it around the sides. Gently guide the creases and folds to form and interesting texture on the canvas. Tear and remove or add more tissue to build additional texture. The original color painted on the canvas will color the tissue and loosely adhere it to the canvas. Let the texture dry. After it dries you can come back and paint with more color or matte medium and let it dry again.

Dry brush DecoArt and Golden Artist Colors Fluid Acrylic paints in a loose grid composition. As I paint over the original color it modifies into grays, browns and blacks.

While the paint is still damp on the canvas, I select several of my hand cut "Signs and Symbols" stamp bocks. These are cut with a Speedball carving tool set using Easy Cut blocks. I use these stamp blocks in countless art projects. Most are cut from 6" by 12" blocks. I have at least 100 of these blocks and I store them in flat file drawers and plastic bins.

Using a 1 ½" house painting brush loosely paint some of the selected blocks with black paint. Stamp the blocks on the canvas to form a focal point. Selecting a ½" round oil painting brush, selectively paint some Turquois highlights and some Red on and near the stamped images.

I select several of my machine-cut stencils – a curved line formed from square dashes, the words "Skylab" and "sky" and a large checkerboard. I use a computer programmable stencil cutter called a Pazzle. It allows me to customize my stencils to meet my text and shape and scale needs with any true type font. Using a Nickel Azo Yellow, Red Oxide, white and black paints I paint through the stencils with a wet brush or a nearly dry brush, often layering several colors. As I remove the stencil I may use a paper towel to smear and soften the edges of the stencil letters or shapes. The stenciled elements are balancing the stamped focal point and leading the eye around the painting.

Using a liner brush I add freehand swoosh marks and lines. If I am undecided I will practice these in chalk first to see where exactly I want to place these. I add more lines using Conte Crayons. These will need to be sprayed to fix them in place after I have faded and smeared the lines to add variation.

Using a dry ½" round oil painting brush I layer and modify areas of the grid to add more direction, light, balance, repetition and variation. Let the painting dry and then evaluate it.

Skylab by Kathleen Mooney, NWS, ISEA-NF. Acrylic on Canvas. 26" x 20"

Roberta Morgan

No advance planning goes into my paintings, ever. I have found that when I plan ahead, the resulting work comes out no better than what is in my head. I have also learned through vast experience that what's in my head is appallingly corny. My experience of reality is one of mystery, of meaningful things filling the universe and continuing in every direction past my ability to see. Such mystery is more than will ever fit in my brain, and so I paint in a way that echoes that, with layers covering other layers.

These paintings are built over a realistic still life. For the painting to be successful, that first layer must be strong enough to stand alone as a realistic image. So I set up a still life with 3 pine cones, 2 small ones from Maryland and West Virginia in front on a piece of fabric, with a large Florida pine cone in the back. To this I added a drop antler.

I spend weeks on the still life, careful with light and shadow, finding ways to keep the details visible, even though some are in the shade. A few days after finishing, I'm beginning to know what this painting is about, and sit with it while writing down relevant words. I reach for words that suggest rather than tell; in other words, I want poetry. If you use text in a painting, you need a strategy that will keep the text from taking over. I make the texts into bearers of mystery. Part of my strategy is rendering the text in Latin and Greek.

This is my favorite part of the painting. I use a swing arm desk lamp with a magnifying glass while I render the words with fine pointed brushes. I have templates for the letters, and draw rough outlines to follow. This isn't ordinary calligraphy. Standard calligraphic technique wouldn't work here, because the painted surface is bumpy, and it absorbs paint differently in some patches. So I get the text on by painting it.

When the lettering is done, I let the painting rest for several days. Then comes the last stage of the painting which I find to be absolutely terrifying. I've been working on this piece for weeks, and now it's time to find a way to repeat the ideas in the painting abstractly, and to end up with a better painting when the process is complete. So I sat in front of the painting, thinking, "What in the world am I going to do now?" I thought of the animals in the woods that are hibernating, and painted a yellow square at the bottom of the painting. Then I thought that this was a terrible idea and began to mop it off with paper towels. In the process I got the texture of the paper towel imprinted in the paint. I liked that, kept it and waited for the paint to dry. Then I added another yellow rectangle.

During that time I decided that I liked the yellow square after all, but it wasn't strong enough, so I added another plane of color. Then I was on a roll, and put in white planes that float to the top, which to me represented the life that dies during the winter. I added a brown plane for all that has to tough it out, and pillars of blue, which are the forces of cold and darkness. Finally, I add two more words on the top, so the layers interact visually.

When I finish a painting I generally have been working on it for enough weeks or months that I hate it. However, I can see that this painting is one of my better efforts.

Winter
By Roberta Morgan
Oil on board
10" x 10"

Patricia Oblack

The base for the painting is constructed of hardboard, mounted on a cradle of MDF with the edge painted black.

Scratching the surface with coarse sandpaper prepares the boards for paint. Approximately eleven inches of the upper surface is dedicated to the off-white section, which is the first portion to be painted. Several whites and off-whites to pale yellows are applied to this section and woven one through the other. As this color temporarily sets, I add markings using pencil, dental tools, scribes & rulers, to create an abstract storyline of sorts. Postage stamps, metal strips, & wine caps are attached. While the paint is wet, various lines and other marks continue to be added as needed, often sprayed with a mist of water.

I begin to lay the foundation for the lower half with six shades of red to orange, using the same technique as above. Beginning just below the white area, ribbons of paint are applied, woven and blended with a palette knife. The size of the knife determines the pattern and texture of the surface. When the entire red area is complete, I apply black to the top of the painting, along the sides and into the red area as needed. I always work intuitively. There is no constructive planning; everything will find its own way onto the surface. As the painting evolves, strokes made with the knife are pulled downward into the red, and the white area becomes stained with a small portion of the red below.

In the red area deep purples are mixed in, to add additional weight to the lower half of the work and give depth to the saturation of color.

Additional black is applied where needed while other various markings are added to the upper portion of the painting. It is during this time that I mist the paint to help blend and soften the colors. After the surface is dry, an additional glaze is added to the red section.

Once the board is completely dry, a varnish is applied to bring the reds back to their brightness from when the surface was wet.

Each of my paintings has a "voice" listed on the back, which often helps the viewer gain insight into the emotional content of the work. Sarah McLachlan was chosen for this piece. Her CD "Rarities, B-Sides & Other Stuff" is the inspiration. The name of the painting refers to the house of sorts that appeared in the upper right corner and a mysterious mailbox , defined by a postage stamp. Stretching across the top are more stamps, which I felt were letters that may or may not have ever been delivered. My paintings always finish themselves; I am just a facilitator in the process.

Disconnected Correspondence
By Patricia Oblack
Acrylic Mixed Media
48" x 64" Diptych

The process begins with a frame constructed of MDF, recessed 1" from the edge & glued to the back of a hardboard surface. This construction creates the illusion that the painting is floating on the wall.

After the surface has been scuffed with coarse sandpaper, I begin to apply small ribbons of paint distributed with paint sticks from 4 separate off-white colors. By using a palette knife, I scrape, smudge and weave the colors, while also taking advantage of the darkness of the board itself to create the beginning backdrop for other textural applications. Paint containing sand and ground stone along with modeling paste helps lay the groundwork for other layers of texture in smaller areas while various screens and grids are pressed into the paste, leaving their marks behind on the surface of the board.

Metal strips, screens, wine bottle caps and galvanized metal squares are also set into place using modeling paste while other red sections are simply painted on. I like to work quickly and keep the surface damp, so that I can continue to make various marks in the surface using pencils, dental tools, putty knives and several types of scribes that allow for cutting of circles, grids, map marks and other details as needed. Balance is always an important factor.

Toward the end of the process a band of black and maroon red color was added at the very top to anchor the overall composition. Across the bottom there are 2 arcs drawn with pencil where the lyrics of the song were inscribed.

I listened to the CD "Whole New You" by Shawn Calvin while painting "One Small Year". The title of this painting was inspired by the song of the same name. In the year 2005 I went full force into fine art & abstraction. I set up a website, had my first showings, was accepted into galleries and began selling my work, all in one small year.

Written on the face of this piece, which is my signature work, there are many notations of gallery representations, paintings sold, levels of emotions, new friends made through networking and so on, all journaled onto the surface, which continues to grow the years pass.

Each of my paintings has a "voice", listed on the back, which may help give the viewer some indication as to how I arrived at the completed work. Abstract is a mysterious process and every artist approaches it differently. Everyone sees their own vision of the surface. In the end, it's all magic and I am but a facilitator in the process.

One Small Year
By Patricia Oblack
Acrylic Mixed Media
48" x 48"

Dr. Craig Peck

My fascination with texture and creating art using new and exciting techniques led me one day to experiment with fiberglass resin. Most of my art that contains texture relies on the texture being rough, which increases the realism of the art by increasing its perceived depth and tactility. I wanted to find a way of using texture that had a softer look and feel to it - more delicate and gentle in nature - and fiberglass resin was just the thing I was looking for!

I decided to create on hard board, given the nature of the resin. I wasn't too sure about the exact image or theme I wanted to convey until I actually started. After mixing the fiberglass and activator to the manufacturer's specifications in a disposable plastic container, I randomly drizzled the mixture over the hard board in about 5 cm diameter blobs. After enough of the board was covered, I lifted the board and allowed the resin to flow down the board in one direction. Then I tilted it in another direction, to allow for flow at about 90 degrees to the first one and so on. until geometric shapes were formed by the resin on the board. Depending on how you orient and turn the board, you will be left with areas included within the resin-demarcated lines that are not covered by the resin mixture. This was left for several hours until the resin hardened and was not tacky to the touch.

When you give this a try, decide on your color scheme. For best results, experiment with contrasting colors – even with colors that you think would not complement each other. Start with the color that you want on the resin lines and brush this over the surface of the entire piece – you can even apply the paint with a sponge and rub it over the surface (I used acrylic). This will dry pretty quickly; don't worry about being too tidy at this stage. Decide then on your contrasting colors (I used two different colors) and start painting the inner shapes contained within the resin-demarcated lines. Depending on the effect you want to create, you can paint this as dark or light as you wish but decide on the intensity of the color by mixing the shade of paint you want from the start. Just as these areas start drying, take a sponge or clean rag and rub them gently to bring out the gentle grain on the hard board underneath, which creates a fine textured appearance contrasted by the smooth and almost shiny surface of the resin lines.

For me, the most pleasing effect was to use two similar colors of varying intensity (call this option A) and two contrasting colors, but also similar, just of varying intensities of color (call this option B). Use one of the colors from option A for the resin lines and the other color from option A for some of the spaces which are formed on the board by the random flow of the resin. Use the other two colors of option B to color the other spaces contained within the resin-demarcated lines. In this way, you get better homogenicity in the appearance or a better degree of unison in the theme you want, rather than have it look like a lot of random shapes that you have filled in with color. When you rub or wipe off excess paint, there will be a degree of smudging. This creates the unpredictability and uniqueness of the technique – it is up to you how much or how little you want to blend the colors. Allow to dry and then spray with a clear lacquer varnish to seal and trap in the colors. Just remember, there are no rules so allow your imagination to create what it wants, without applying an overly critical eye – and most importantly of all, have fun with it!

Denim Sky by Dr. Craig Peck
Mixed media 90 x 110 cm

My fascination with texture and creating art using new and exciting techniques led me one day to experiment with fiberglass resin. Most of my art that contains texture relies on the texture being rough, which increases the realism of the art by increasing its perceived depth and tactility. I wanted to find a way of using texture that had a softer look and feel to it - more delicate and gentle in nature - and fiberglass resin was just the thing I was looking for!

I decided to create on hard board, given the nature of the resin. I wasn't too sure about the exact image or theme I wanted to convey until I actually started. After mixing the fiberglass and activator to the manufacturer's specifications in a disposable plastic container, I randomly drizzled the mixture over the hard board in about 5 cm diameter blobs. After enough of the board was covered, I lifted the board and allowed the resin to flow down the board in one direction. Then I tilted it in another direction, to allow for flow at about 90 degrees to the first one and so on. until geometric shapes were formed by the resin on the board. Depending on how you orient and turn the board, you will be left with areas included within the resin-demarcated lines that are not covered by the resin mixture. This was left for several hours until the resin hardened and was not tacky to the touch.

When you give this a try, decide on your color scheme. For best results, experiment with contrasting colors – even with colors that you think would not complement each other. Start with the color that you want on the resin lines and brush this over the surface of the entire piece – you can even apply the paint with a sponge and rub it over the surface (I used acrylic). This will dry pretty quickly; don't worry about being too tidy at this stage. Decide then on your contrasting colors (I used two different colors) and start painting the inner shapes contained within the resin-demarcated lines. Depending on the effect you want to create, you can paint this as dark or light as you wish but decide on the intensity of the color by mixing the shade of paint you want from the start. Just as these areas start drying, take a sponge or clean rag and rub them gently to bring out the gentle grain on the hard board underneath, which creates a fine textured appearance contrasted by the smooth and almost shiny surface of the resin lines.

For me, the most pleasing effect was to use two similar colors of varying intensity (call this option A) and two contrasting colors, but also similar, just of varying intensities of color (call this option B). Use one of the colors from option A for the resin lines and the other color from option A for some of the spaces which are formed on the board by the random flow of the resin. Use the other two colors of option B to color the other spaces contained within the resin-in-demarcated lines. In this way, you get better homogenicity in the appearance or a better degree of unison in the theme you want, rather than have it look like a lot of random shapes that you have filled in with color. When you rub or wipe off excess paint, there will be a degree of smudging. This creates the unpredictability and uniqueness of the technique – it is up to you how much or how little you want to blend the colors. Allow to dry and then spray with a clear lacquer varnish to seal and trap in the colors. Just remember, there are no rules so allow your imagination to create what it wants, without applying an overly critical eye – and most importantly of all, have fun with it!

Lavender Dreams by Dr. Craig Peck
Mixed media 90 x 110 cm

Lee Pina

The painting process for me always begins with some sort of texture. After painting on plaster and sand, I wanted to see how acrylic paints and media would play on tissue paper. Using the gallery wrap canvas as a support, I began applying crumpled tissue with a light coat of water mixed with gesso.

With the tissue loosely applied, I sealed the edges with gesso. I then used a hair dryer on low speed to create contours and shapes in the tissue. The heat caused the tissue and gesso to harden creating raised edges and depressions to attract the paint. Once happy with the patterns, I allowed it to dry completely and applied gesso to any spaces left at the edges.

I lightly applied several thin layers of a watered down blue palette with ¾" and smaller brushes to form a background. Building layers of depth, I added purple, grey and black acrylics to the foreground. Throughout this step, I bubbled and dried the canvas with the hair dryer on high speed. A layer of matte varnish was sprayed and left to dry.

Next, I added undiluted white pearlescent with a 1 inch flat goat hair brush. The roughness of the hairs makes it possible to create irregular vertical patterns. Once dried, I added yellow highlights to the raised tissue by holding a ¼" flat brush parallel to the canvas.

This is probably a good place to stop but maybe not yet! I found a tube of black paint that was almost dried up. There were only gobs of paint left, so I squeezed it randomly to catch the tissue and allowed it to dry overnight. Several coats of clear gloss varnish were sprayed on until the entire surface is hardened. Now it's done!

This piece is very special to me as it represents the beginning of my journey as an artist. I love experimenting with anything that will bring a piece to life with its own voice, and texture is that voice. Everything else emerges from it.

Journey
By Lee Pina
Acrylic
14" x 14" x 1½"

After using tissue on a support, I wanted to explore using it as the primary support. Tissue is thin and tears easily when wet, so I used two layers of 20″ x 20″ tissue paper. After crumpling it to create grooves and edges, I spread it loosely to about 16″ x 16″ and placed it over a sheet of wax paper. The wax paper allowed me to move the piece while it dried without disturbing the wet media.

I applied concentrated watercolor directly from the 2 oz. containers onto the peaks in the tissue paper. The concentrated color is extremely vivid and seeps unpredictably into the crevices.

At this point I have options. I can apply different colors wet-on-wet, add water to diffuse and roll the color around the tissue or let it dry before adding more color. I choose to go with wet-on-wet without water. Moving the wax paper only, the colors blend unpredictably and saturate the surface.

Left to dry overnight, I can lift the tissue from the wax paper, careful not to make a tear. I chose a 10″ x 10″ primed canvas for a support and lightly covered it with Elmer's Spray Adhesive. The piece was lightly pressed onto and around the edges of the canvas so the textures remain slightly raised.

Excess tissue was cut from the back with a straight edge and Exacto knife to shape with the canvas frame. The last step was to apply several layers of high gloss varnish to the surface, sides and back with a flat brush.

This process is totally unpredictable which makes it exciting and truly a creation from within!

Pieces of Me
By Lee Pina
Watercolor
10" x 10" x ¾"

Isabella Pizzano

After fifteen years of dedicated involvement in learning different art techniques under the tutelage of renowned artist-teachers, I recently decided to develop my own style and personal techniques.

My past experience with clay sculpture enabled me to experience and enjoy the creative process of exploring abstract shapes: bas-relief, different shapes and lines, marks and imprints, etc. At present I'm doing the same with my collages.

Most of the time I work on illustration board and sometimes I use plywood treated with gesso.

The most exciting part of the process is hunting for rare and far-fetched papers: I brought some back from China and Nepal, and some from Japan. I really admire the quality of their rice papers. Other sources are handmade paper from South Africa, and I know they are using natural plants as the main ingredient, in addition to local mineral dyes. Actually one of my favorites comes from the banana peel! My only concern is seeing this festival of colors fading away on my artwork in future years.

My supply of papers occupies one-third of my studio and most of the time they are in a disorganized mess! It's a pleasure to process and prepare these fine papers for the final process with a treatment of acrylic and watercolor and my own personal stamping, as well as oil sticks and water soluble color pencils.

I always believed in the importance of creating stamps with my own design because I don't like the commercial look.

The process always starts in the same way: first I select the materials in a color coordination of my choice and after the selection I tear or cut the papers according to my design. I place the cuttings on my board and study the situation moving the pieces until the best composition appears.

Once satisfied I glue all the cuttings one by one using acrylic matte medium and regular paper glue.

I don't have a specific subject matter or any precise plan. I consider myself an artist using an intuitive approach without a pre-conceived vision of the end result.

Conversation
By Isabella Pizzano
Water media collage on Crescent illustration board
37" x 37"

Susan Prinz

I began with two 16" x 20" stretched canvases because I was going to create a diptych painting which is two pictures that go together. Some artists have used the term in the title of their works describing two paintings intended to be hung together as a pair but can be sold separately, since each picture is complete on its own merit. I started these pictures in my Florida studio on a bright beautiful sunny October day. I wanted the pictures to be colorful and electrifying like I was feeling that day. So, I started pulling out shades of acrylic paint that I love.

When I paint a diptych painting I work on the two canvases at the same time while using the same colors. I start by putting color on my canvas using a 1" brush. I put down the lightest colors first on the canvas and graduate to the darker colors. This allows me to use the same brush without having to keep cleaning it. I place my canvases side by side so that when I apply my conception it ends up in a coordinated and thoughtful design. I keep mixing paint until the right shade of color appears. I apply paint and let it dry, and come back in areas and add new and different colors to make the picture "pop".

Floating Ribbons #1
By Susan Prinz
Acrylic
16" x 20"

I knew I was going to have floating ribbons as part of my design because I was trying out a new paint brush that has spaces between the bristles. Using various sized paint brushes, I drew what I considered to be floating ribbons and let it dry. I then used a ¾ inch ridge paint brush and went over with a different color paint to make it look like ridges in the ribbons. I then made dashes with a fine paint brush and acrylic pens, and sealed the paintings with satin varnish.

I really like abstract art; I find it to be more creative for me then painting a picture of something I am copying. I find the paint has a will of its own and you need to learn how to go with it. Just keep making adjustments until you like the final results. I am always surprised because things keep changing up to the very end of the painting; there is nothing but your imagination to use as a reference. I just keep tweaking my work until it is finished in my own mind.

Floating Ribbons #2
By Susan Prinz
Acrylic
16" x 20"

Barbara Ragalyi

Visual music which is energy, the essence of life, is what I create.

I receive three messages when I paint: Start, What if..., and Quit pickin'. I do not begin with a preconceived idea. One day I just "know" what paint to apply and/or feel a couple of lines indicating shapes. After this initial step I sometimes immediately know what to do next, other times it takes awhile. Then I just keep asking "What if...", until one day I "hear" a loud "Quit pickin' ". At this point I am usually making small adjustments. I set the painting aside, then take it into the house where I can look at it occasionally. If something bothers me, I fix it.

This painting is on stretched Blick Premier 10 oz. cotton canvas which I treated with 2 coats of Golden GAC 100, to create a barrier to block the future possibility of support-induced discoloration (SID). Then I taped off the center section (future yellow and light blue areas) with blue painter's tape and sealed the edges with a mixture of 2 parts soft gel gloss to 1 part water (isolation coat). Some color did seep under the tape.

Underpainting: Golden glaze patina green brushed on and sprayed with water, covered with shrink wrap (the plastic the canvas was wrapped in). Let dry, then peeled off the plastic and removed the tape. I taped the right edge. Using a mouth atomizer I sprayed Golden airbrush Hansa yellow light on the left side. Later I sprayed airbrush transparent phthalo green (blue shade), building layers in some areas. For the right side I taped the yellow edge and sprayed airbrush turquoise (phthalo). Later I sprayed airbrush phthalo blue (red shade) in some areas, again in layers. Zinc white was brushed along the edge of the lightest blue area.

For the circle I cut a paper stencil and taped off the light blue section and sprayed airbrush transparent dioxazine purple, varying the amount. On the blue side the purple remains purplish but on the green and yellow it turns the interesting orange color, which I expected. If I had applied a purple underpainting then sprayed it with yellow, it would have turned greenish. The yellow-purple complement is the only one that makes such a radical shift--fun to play with!

I finished with an isolation coat brushed on. After letting that dry well, I applied 2 coats of Golden UV gloss varnish spray for protection.

Unfolding Universe
By Barbara Ragalyi
Acrylic on Canvas
30" x 24" x 1.5"

Gayle Rappaport-Weiland

The first and most important step of this painting was choosing the paper shape, a square. Taping the paper down to create an edge and a guide line for later matting is helpful. The paper I used is Arches 140 lb. rough paper . I love the textural component that this paper adds to my artwork.

Now I take my art masking fluid and save areas that I want to have highlights. Remember, it is important to soap your round brush before dipping into the fluid; this will save your brush. The light areas are saved. The masking fluid should dry until tacky to the touch.

Wetting my paper thoroughly with a 2" flat brush gives me a surface where my paint will move freely without hard edges. In watercolors I work light to dark, choosing fabulous earth tones that resonate with my inner exploration of organic abstracts. Working with my largest brush first and continuing with smaller brushes as the paper dries, I add deeper values of the same limited palette. At all times I am thinking about the unity of my work.

Next, when the paper is completely dry I rub off the art masking fluid with a rubber cement pick-up to reveal the whites I have carefully saved. I now add the light tones with a round brush to the saved whites which make those areas sparkle.

The fun technique is adding the textural delight. In this piece the leaves, rice papers, and mica gel add that element of surprise. The papers and leaves are all applied using a pH neutral glue with a stiff bristle brush. It is important to glue both sides of the paper. I work so the additional materials create both a rhythm and balance in the piece.

The final touches include adding the darkest values, crosshatching line work and stippling to create a unified abstract that communicates the "Landscape of The Soul."

Landscape of the Soul
By Gayle Rappaport-Weiland
Watercolor/Mixed Media
27" x 27"

M.S. Reynolds

Working in a series is always fun for me. This painting is the first in a painting series on canvas, the subject being "Talk". "Talk" covers small talk, sweet talk, old talk, kid talk, tech talk, many kinds of communication humans have used through the years. (Examples: pony express, telegraph, tweet, You Tube, e-mail and paper cup/string etc). I am still working on this series.

Recently I have overpainted some art that I felt wasn't working. Much of my work, whether on canvas, paper or wood, involves layering paint, scraping back, lifting and adding more layers. This is fun and offers lots of good surprises. I always use a lot of line and mark elements in my work as well as texture and color.

In this piece, the original painting had a lot of orange, blue, navy, gray and brown hues. These paints were Utrecht heavy body Artists' Acrylics, which I always use in my canvas work. I overpainted with Titanium White and left lots of different-sized colored shapes showing. Also for interest and variety, I let a little subtle color show through on some of the white areas. I like to work fast and take advantage of being in the zone of the right brain. While the paint was still wet, I rolled a carved wooden cylinder (found at a garage sale by one of my students and gifted to me) across the white paint to create texture in many of the white areas. Then I used a ¼ inch "shaper" to cut into the white, creating lines connecting the various colored shapes. The shaper is a rubber brush used in sculpture and comes in different sizes and shapes, lots of fun to use. The last big blue mark on the right of the piece was a spontaneous addition, representing an exclamation mark saying I was happy with the work and that I was DONE!

Tech Talk
By M.S. Reynolds
Acrylic
36" x 36"

I have many mental images and personal photographs of mountains and desert areas: I lived in Arizona for several years and traveled throughout New Mexico and Arizona in the 1980's and 1990's. The shapes and colors have stayed with me and are a constant presence in my subconscious. Many of my paintings reflect the love and interest I have for the West. This painting with a limited palette was chosen to portray the Navajos of northeastern Arizona approaching a butte/plateau on their reservation area that I visited.

I worked flat on a table for this process. The 300# Fabriano hot press paper needs newsprint tucked under all the way across at the bottom to catch the excess paint. I worked this in a vertical position.

The first step was to cover the paper with a mixture of gloss medium (70 %) and water (30%), and allow to dry thoroughly.

The paint was applied by squirting burnt sienna, burnt umber and phthalo blue mixed with some sepia to darken it, onto the top half of the paper. These hues were put into plastic bottles with squirt tips to put the paint on the paper in skinny lines that crossed and ran over each other. A lot of paint lines must be applied so that it is enough to cover the whole paper. While this was still fresh and wet, I pulled the paint down to the bottom of the paper with a large, 10" wide, squeegee, in a continuous motion. I continued this technique until the paper was covered with the pigment. (You cannot get all the paint lines at once unless you find a 22" squeegee!) I learned this idea in a workshop with Lana Grow and we did it on a one-quarter size sheet. I just took the process to the next level for a full sheet.

While the paint was wet, I sprayed some alcohol in a few places for texture, and then used brushes called "shapers" to scrape some of the paint back to the white of the paper. I mixed my own gouache with burnt sienna and titanium dioxide. This gouache was used to carve out the shape of the mountains/butte area to separate the approaching figures from the mountains, and adding some to the foreground to pull the figures out and tie in with the top gouache area.

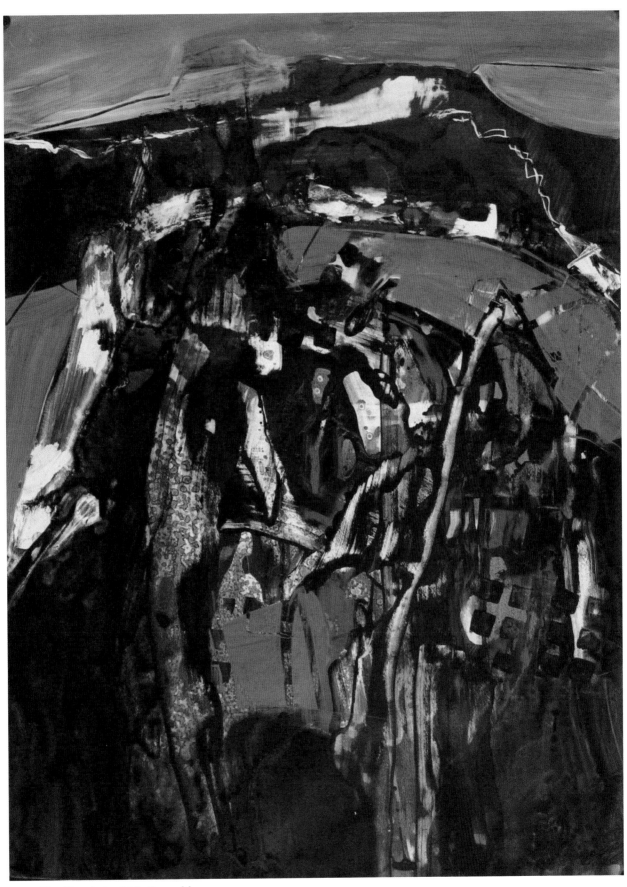

The Navajo by M.S. Reynolds
Acrylic. 30" x 22"

Jane Robinson

This painting was inspired by one of the most important figures in twentieth century American music. Charles Mingus was a virtuoso bass player, accomplished pianist, bandleader and composer. In the 1950's and early 1960's, Mingus found himself at the forefront of the avant-garde jazz movement. The rhythm and syncopation in his music are the accentuation of a beat that normally would be weak according to the rhythmic division of the measure. By listening to Charlie Mingus the intuitive act of creating is predominate in this painting...bold, colorful, and syncopated rhythms.

My paintings are always somewhat large so I begin with a canvas measuring 36" x 36". First I begin with a coat of white gesso covering the entire canvas. I then apply a sculptural medium and place small granular nuggets in it for texture. This must be completely dry to begin the painting (which usually takes 24 hours).

I then turn on my jazz inspiration and for this painting it was Charlie Mingus. I use Golden Fluid Acrylics which have wonderfully deep pigments and pour with the consistency of heavy cream. I use Hake brushes which are high quality with hand-bound soft goat hair bristles which do not come out while painting. The brushes are good for washes and hold lots of fluid.

Once I select my color palette, I allow the intuitive process to take over. I almost never have a preconceived plan or design in mind when I paint. I immerse myself in the process not allowing my inner critic to speak during this time. Afterwards if I am not pleased with the outcome I leave it for a day or two and return for a fresh look. At that time I can decide if I want to make any changes. Often what I think is a mistake becomes a painting I am pleased with in the end. Once completed I pour an epoxy finish over the entire canvas giving the surface the appearance of glass.

When you view my work try to see it without any preconceived notion about art "should" be. Look at the color, the energy and the rhythm – Charlie Mingus.

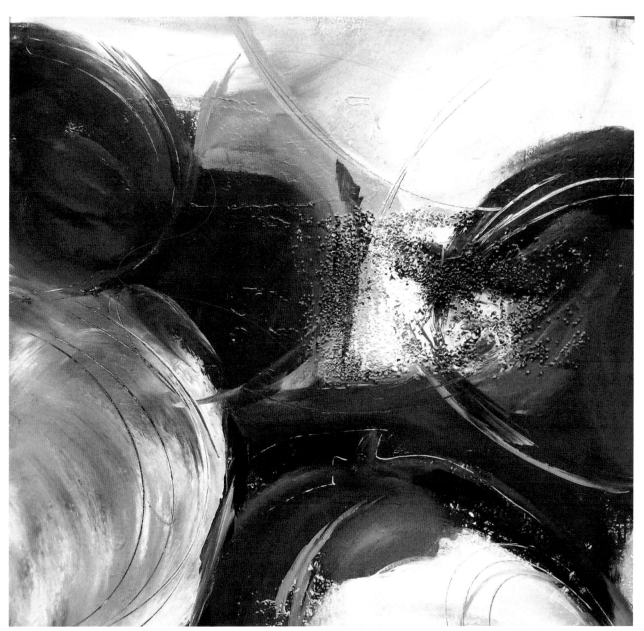

Charlie Mingus
By Jane Robinson
Acrylic
36" x 36"

Kathy Blankley Roman

This piece is one of my favorites. It was the first one where I was successful in creating see-through layers with large, simple areas of color running in and out of scribbled lines. It is built on a loose underlying grid - a process I frequently use when my paintings start to wander or become uninspired or unsatisfying.

I started with Kraft paper - I really love this surface for its color and the smooth working surface and it complements my preference for earth colors. I find that using a colored background tends to strengthen the painting and gives more depth to the color, allowing use of transparencies that remain within my limited palette. I tape it to a board with painter's tape to control warp while painting, creating a clean brown border of about 1/4" around the finished painting. This is usually covered up by a mat when the piece is framed, but I like the look of it.

I started by drawing in a loose grid with charcoal – using sweeping strokes running top to bottom, rounding at the edges and back again, and then the same thing going across, all without lifting the charcoal from the paper. This was done very quickly without much thought. I ended up with a suggestion of a 3 x 3 squarish grid, some lines running off the paper, some rounding off well short of the edge.

At this point, I started to lay in flat areas of raw sienna loosely within the grid - in the upper right, along part of the left side and in the lower right corner. Then I added the white. A few more scribbles with the charcoal, and then some yellow ochre at top left and center, where it overlaps into the white. The darkest areas are the result of the interaction between the charcoal and the raw sienna when the paint passes over and smears, in combination with the color of the paper. I love the deep rich color that happens with this combination. Regular opaque raw sienna doesn't have the same effect; it must be transparent. The cool grays also happen with the interaction of the charcoal smearing with the thin white paint. The cooler brown in the center is the uncovered paper, as well as in barely visible areas at lower right edge and center left edge.

I usually paint with a relatively dry brush, well coated, with just enough water to allow it to flow. In the two white areas, you can see the thicker, drier application of the paint that has then been thinned and pulled out from the initial strokes. Also, on the center left edge you can see the color of the paper through a dry brush stroke.

This was one of those pieces that was so exciting to do - "aha" moments happening all over the place. The trick was to stop before going too far, something that is always a challenge to me.

Materials: Acrylic paints - transparent raw sienna, yellow ochre and titanium white; a square charcoal stick, broken to about an inch or so long; 1" white nylon flat brush (a cheapo from the craft store); 12" x 12" brown Kraft card stock (from the scrapbooking section of the craft store - archival and lightfast).

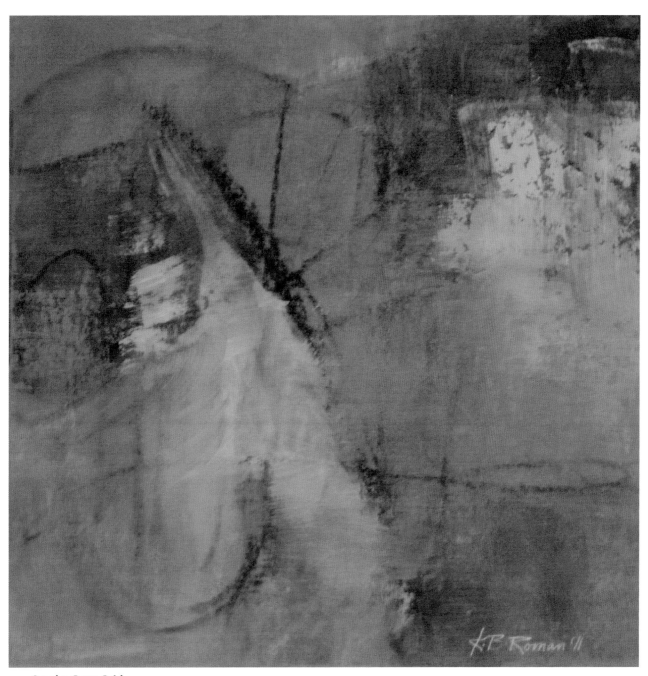

Smoke Over Grid
By Kathy Blankley Roman
Acrylic
12" x 12"

This piece started out as a collage using a digital print of a Von Gogh painting – I don't remember which one, but it was probably one of the brightly colored landscapes that I love for the colors. The print has been cut and ripped into roughly vertical strips. I usually start by affixing these strips in staggered columns across the page, using matte medium as the adhesive. Then I started to paint using similar colors from the painting, pulling them out from the collage strips, quickly and without much thought or plan, often visually eliminating the edges of the paper. Next, I drew in some scribbles and marks with charcoal and then went back over some of these marks with paint. I added some white to brighten it up, as most of the area had become dark and muddy. It didn't help much. This particular piece was going nowhere fast. I added a few more charcoal marks and at this point, decided to use my rice and tracing papers to try to "save" the painting.

I wanted to preserve the areas that I liked - the brighter colors at the top and the red at the bottom and some of the darks for contrast, a mixture of burnt umber and ultramarine. I started by laying in the torn hyacinth paper in patches, overlapping across the center of the page. Using this technique, it is important to maintain at least three distinct values in the underpainting - light medium, dark - otherwise the layers and depth will be lost in the overlays. Using the matte medium as adhesive, I brushed some on the underside of the paper and/or on the painting where I planned to place it. I then used the brush to work it in, brushing and pushing the medium out from under the paper. This is rough on brushes, which is why I only use inexpensive brushes - they take a real beating. The paper becomes almost invisible when snuggly adhered, except in the areas where there are air bubbles left because of incomplete adhesion (some areas missed getting the medium on the underside, which creates the air bubbles). It also becomes even thinner, through working hard with the brush on the wet paper -

this actually removes some layers of the paper, sometimes tearing it and leaving little "skumbles". I added some of the tracing paper on top in the area just right of center - it is white and relatively smooth and, though nearly transparent when applied, gives a cooler gray tone to the warm tones of the hyacinth paper, beneath and above. One place where you can see the effect of the white paper is the long, sort of triangular shape pointing down from the top right corner. Another is the gray area just right of center. The same effect of air bubbles gives these areas a more opaque white tone. At this point I took a break to stand back to see what was happening, making sure that some of the charcoal marks are showing and checking for balance in the overall composition.

I decided to add some more of the hyacinth paper down the sides and running off the edges. What looks like striations in those areas is the impression left by the brush on the transparent paper as I smoothed it out, leaving long, thin air bubbles that didn't get adhered. Because the paper is so thin, the charcoal marks are easily visible underneath. Another larger piece was placed just under the color at the top right. You can see the outline of the piece that is adhered tightly in the center but not on the edges and there is a big rip in the paper, allowing a hole that reveals the paint underneath. Using the hyacinth paper to run off the edges helped to pull the different sections together and added both motion and depth. At this point I decided to stop, as I was satisfied that it held together with a nice energy and depth. The original collage from which I got my colors had now become totally obliterated.

Materials: Acrylic paint - cadmium red light, titanium white, cadmium yellow medium, burnt umber, ultramarine blue; square charcoal stick broken to about one inch long; white tracing paper (it comes on a roll and is called "sketching paper"); acrylic matte medium; hyacinth paper (a "rice" type of paper that is a pale tea color and is very thin, almost transparent);

1" flat white nylon brush - a cheap one from the craft store; Canson Infinity 300# Arches Aquarelle Rag textured paper (Inkjet Fine Art and Photo Paper). Note: I purchased the paper for printing high quality reproductions on my printer, but it was too thick to go through. I use it now for my paintings that incorporate collage. Its stiffness is an excellent base for this kind of work.

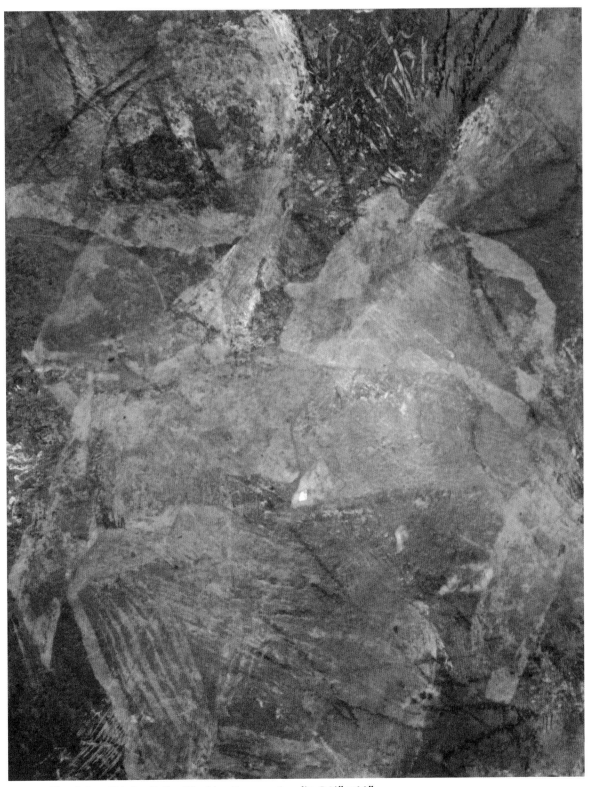

The Other Side by Kathy Blankley Roman. Acrylic. 8 ½" x 11"

Chris Romine

As an experimental mixed media artist, I use a lot of texture, techniques, and color. I started with a 30″ x 40″ stretched canvas. I use many layers before a painting is completed. This piece began with a design created with pre-mixed cement that can be purchased at the hardware store. Golden's lava gel is similar, but I like the consistency of the cement. The application of cement was done with a Mason's trowel and smoothed to the level of texture I wanted. While the cement was wet I created designs with a notched plastic "thrifty trowel" also available at the hardware store.

At this point, I added collage papers to the upper middle to define and enhance my design. I used Nova heavy gel (209) to attach my collage papers. After the cement dried, acrylic paint was applied. Liquitex gold was painted first around the cement. Next I briefly sprayed gold Krylon webbing in the upper right and left corners for additional interesting texture. The paint was applied with a 2″ Bright Artist Loft synthetic white brush. I then buffed the application of each color with a 2″ Hake brush which I have shortened and shaved to help blend and spread the paint. The acrylic colors I used were all Golden products: cobalt teal, transparent red iron oxide (my favorite), and quinacridone burnt orange. The chinese lettered stamp image in the lower middle and right corner was done by applying black acrylic to the stamp and then printing it.

The final application was to brush gold leaf adhesive on the cement design. After it dried to a tacky consistency, I applied the gold leaf. Both the gold leaf and adhesive were purchased online from Easy Leaf Products. The gold leaf will tarnish if not protected with a sealer. In this piece, I used Golden's micaceous iron oxide to tone down the brightness of the gold which also added a seal to it. The final coat I used to seal the entire piece was Nova gloss medium (206).

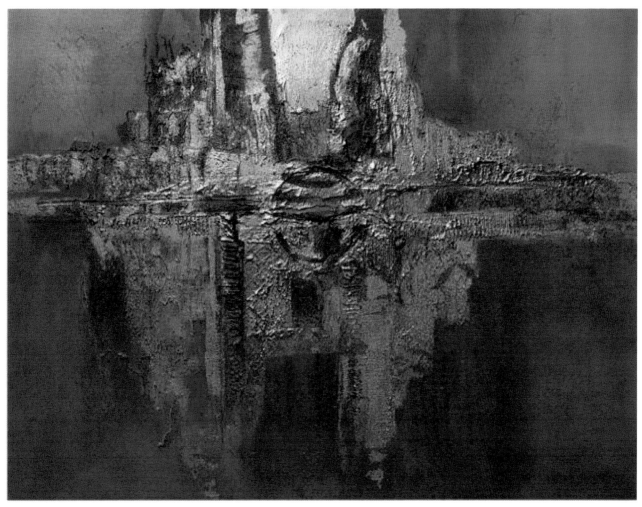

Golden Glory
By Chris Romine
Mixed Media
30" x 40"

Judy Schneider

The genesis of this piece began decades ago. Shortly after my divorce, I donated two red foam sofas and bolsters to Russian émigrés setting up new homes in America. As I watched them transport my old furniture to their van, it occurred to me that they probably felt they were just taking away my sofas to use in their apartments. I, however, felt they were taking away a large chunk of my history. I needed to express that in some way.

Fast forward through 25 years of painting and printmaking. In my studio I had started a monotype using red and orange oil-based printing inks on Rives BFK printmaking paper. As is frequently my way, I had no idea in what direction this work would go. As I saw the print come out of the press, it suddenly came to me! What a perfect start for a piece related to the red sofas of yesteryear. I set the print aside to dry.

A few weeks later, I found some red cotton fabric- the perfect color to match the original sofas- and cut pieces to the size I wanted. I used pinking shears on some pieces. As an homage to my dad, who stitched utility naugahyde covers to protect the sofas from children and a dog, I used some of the red material.

I dug around in my vast collection of bits and pieces of papers (for collages) and found the snippets I wanted to use to create a figure to sit on the sofa, and for additional accessories in the room.

Using matte medium, I glued the various pieces onto the print. When they were almost dry, I covered the entire work with waxed paper and used a brayer to flatten them out. I allowed it to dry completely. I then made minor adjustments and additions.

When I felt the composition was satisfactory, I used a sharp, very soft Ebony pencil (graphite) to write and hand print on the piece. The happy memories were designated to the sitting surface of the sofa, and the negative memories were under – being pushed out of sight (and memory).

It felt very good to have finally resolved an idea that had been percolating for a very long time. It seemed so simple when I finally started working, and it was the start of a new series of work!

The Red Sofa (The Fabric of Life Series)
By Judy Schneider
Mixed Media
29.5" x 25.25"

Eric Harley Schweitzer

"Painting in the moment allows me to capture what I feel at the moment. It is a way of living frivolously, vicariously and eternally, within only the rules I see fit."

I began this painting as I usually begin all new works- without any idea of what it will or should become. I rest my assertions on chance and have found that in art, beauty and harmony often come most easily through happenstance. Therefore, I am heavily reliant on my instincts and an action-style painting technique that allows me to spontaneously project my immediate conscious and subconscious mind, via free-flowing gestural black lines onto canvas. Using house paint allows me the flexibility to get these lines down on canvas rapidly and without having to stop to reload the brush. Depending on the size of the canvas, in a matter of a few hours the fate of the work is sealed (that is unless it is completely "white-washed" and started all over again) and I now have what I use as my forward template. At times, while applying these black lines I even kept my eyes closed.

Working loosely at first and then tightening up any happy accidental nuances that emerged on their own, I continued manipulating these lines until they reached a point of becoming mildly recognizable significant forms deserving further attention. These forms were created while constantly turning the canvas. Doing so invites new forms and realizations, as well as challenges that keep the painting from becoming stagnant. At this point, I began to turn my attention to carefully sorting out themes and compositional structure. Opening up new forms and further ignoring forms that have less potency or relevance towards the harmony of the work is what matters most at this stage.

Overworking a canvas is extremely easy and what I concern myself most with while dividing a space (in this case maintaining these divisions in a balanced and efficient manner) is ensuring a peaceful work. At this point color is applied, which I use as a means of creating depth and perspective along with further balancing forms and affixing their positions in space. Layering paint is how I achieve a wonderful way of creating complex intermediary colors and texture, often through wet-on-wet application. House paint dries very quickly and in a matter of several minutes I can reclaim a lost form or enhance another. Atmospheric yellow is a dominant color in this work. This wonderful blend of hi-tonal hues and its translucency afforded the blue underpainting to carry through and further create an apparent 1:1 balance of yellow to blue hue throughout the composition. I used a warm pink hue for the dominant abstract arm/thumb/head form, red line matrices and other artifacts to imply motion, and included several blue/white abstract forms in the negative space. This in turn gave the work that balanced perception of all three primary colors, one of the main tenets of my work.

This painting represents one year of work from start to finish. With an extreme explosive and impulsive beginning through progressive layering and relayering to a planned construction and eventual dénouement, the result is in keeping with my unbridled abstract figurative goal in mind. Less is best, gravity undetermined, line absolved, and in the end, unity. It is my deepest joy to be able to share this reflection of my mind and permanently declare what I feel it means to be human and alive today.

Happy Man, II
By Eric Harley Schweitzer
Enamel house paint
54" x 54"

Alan Soffer

My process for creating this painting was in keeping with my overall approach as an abstract expressionist painter. I believe that deep in my subconscious lurk all the really important fragments of my being. Through some miracle of alchemy, telepathy, or psychic transmission I manage to tap into it. I have used the term channeling to express my path to the "zone."

I know this is starting to sound a little too spiritual, but so be it. I wouldn't want anyone reading this to suddenly think that by following the Soffer formula a work of art will be born. It could happen, but don't count on it. One has to hone this skill of reaching down fearlessly, facing failure, digging in, overpainting, scraping, adding another layer of paint, glazing over, rethinking the original premise, if there is one, and having faith that there is light at the end of the tunnel. Yes, even Matisse had at least 30 layers of paint in every painting. So the hope is that it won't look overworked, even if it is. If you want perfection the first time around, buy the "painting by numbers" system.

But for those who want to know the step by step, here it is. When working large in the encaustic medium, hot wax to the uninitiated, I generally do a simple underpainting with watercolor or tempera. This gives me a sort of guidepost to begin the painting. I am not expecting the final painting to look anything like this underpainting, which would be the case in a representational painting. Here I used a combination of tempera and collaged photographs from a Korean newspaper. I love Asian calligraphy. If you were able to see this painting up close you will see that I have expanded on the calligraphy with a version of my own.

As the work progresses, I become more and more an instrument rather that the controlling force. So I can't say why I chose the color scheme, other than it simply was demanded by the work itself. Now as I see some clear construction of space, I start to work more from my consciousness. I am making decisions about value, color, texture and composition. Somehow there needed to be a few lines in the foreground to create a feeling of depth and contrast. Frequently it will take days to discover the mark that is needed to fulfill the demand of this new entity. I can't really remember how long this took, but I do remember that I worked on this painting a long time.

Militarized/Demilitarized is a very important painting in my oeuvre as it lead to the Solar series through its many offspring.

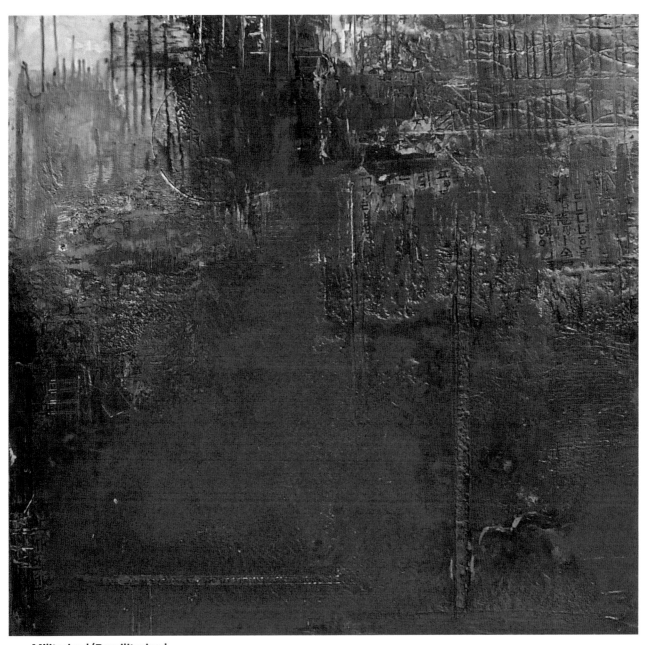

Militarized/Demilitarized
By Alan Soffer
Encaustic and collage on board
32" x 32"

Pat Stacy

"The tip of my brush is the tip of my soul" (Alexander Hamilton) and so it is for me. I call myself an intuitive artist—I begin with a loose idea and let the painting lead me. I never know exactly where it will take me. My process for working on canvas always begins with texture. I like to use Golden modeling paste underneath, using wire, screen, stamps, combs, or just about anything to play in the paste. I try to make a pleasing distribution around the canvas—but I really have no idea how the canvas will look. After letting it dry, I pick a color palette. Usually I like a limited palette accented by metallic and interference paints. I apply a base coat of diluted color over the whole canvas and then I use titanium white and a dark, going over the canvas with a palette knife to give more texture and depth. I begin thinking about my process at this point. One way I often go is to divide my canvas into rectangles of various sizes. I begin to put the colors of my palette into these shapes. In this painting I used primarily transparent pyrrole orange, napthol red light, hansa yellow medium and light, and quinacradone magenta fluid acrylics. I arrange the colors in a pleasing way to me, let them dry, and then the fun begins. Using a palette knife, I put heavy body titanium white over much of what I have done, let dry, and go over again with the fluids, smudging or obliterating boundary lines, altering the painting. Since fluid paint is more transparent, the lights and darks come through. After it is dry, once again I go over the painting with the titanium white, and again I come back with my color, adjusting line and design. I do these layers because it adds depth to the painting and gives me time to get the real feel for the painting. I may do this another time or two, each time adjusting the lines of the rectangles, dry brushing one color into another, and making use of the texture in the background.

In "Colores del Corazon", I got to a certain point and said, "I think I want a heart in it—how will it look?" I painted a magenta heart on a piece of watercolor paper and stuck it on the painting to have a look. I liked it—I love hearts and use a lot of them. I drew the heart on the painting and painted it—and it looked like it had been stuck on, just like the paper one - not good. I blended yellow into the edges to soften it and push it back a little, and it worked.

I searched for ways to put the symbols that I love into the painting. You will see a spiral - for me, the journey to the center of being - on the upper left, pushed back with a little yellow. To the top right, you see my descending golden squares, not only given good contrast with some hard lines and reflection, but a symbol I use to denote the light of the Creator coming into the painting—an acknowledgement that our artistic work comes from a deep well inside that we did not form—and I say "thank you". Last but not least, I put my Entity in with the light of the Creator touching the shoulder. It is a symbol I put somewhere in every painting, usually in interference paint. The Entity can be "in your face", or it can be very elusive. In this case, it is seen but is not the focal point of the painting. Rather it simply leads you upward around the painting. When I have finished the painting, I try to finish the sides and rim of canvas at the back neatly and with quality, often continuing with the design and colors of the painting. Last but not least, I use Golden polymer UV varnish to even out the finish—I like the look of good polished shoe leather all over—not too shiny and not too dull.

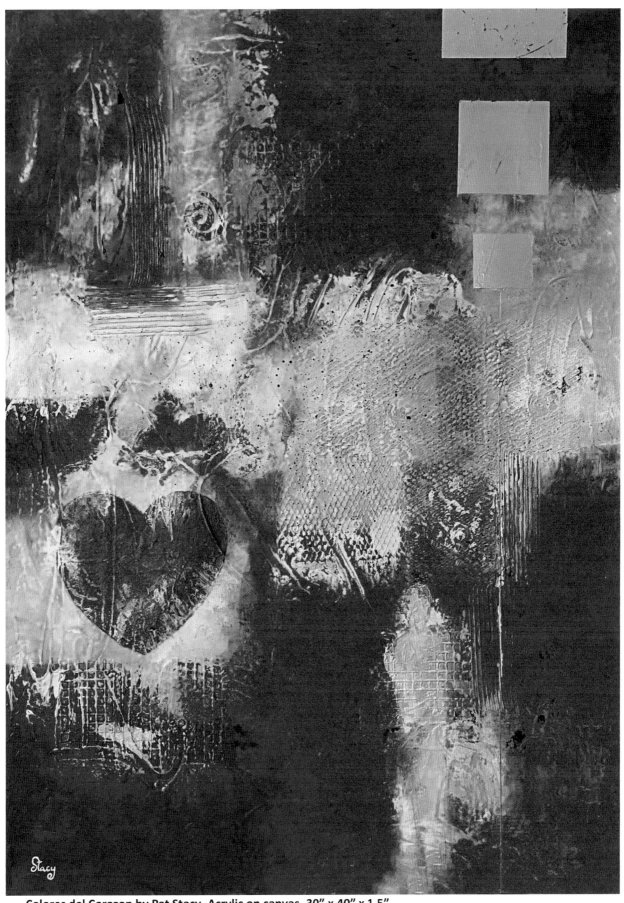

Colores del Corazon by Pat Stacy. Acrylic on canvas. 30" x 40" x 1.5"

Cecilia Swatton

I sprayed water randomly across a blank sheet of Arches 140 lb. watercolor paper, then sprinkled powdered charcoal over the surface. After the paper dried, I shook off the excess powder and sprayed the paper with fixative. With watercolor on a small flat brush, I painted in negative spaces to create rounded shapes that overlapped.

After the watercolors dried, I used watercolor pencils and crayons as well as acrylic paint to further define and highlight the spheres; with the same media, I further developed the background areas. The translucent quality of the original watercolor enabled me to leave some of the spheres translucent. Other spheres became opaque as I added highlights and details in pencil, crayon and acrylic paint.

Along the lower edge of the artwork, there is very little development of the spheres; I used watercolor washes here, as a way of making merely a visual suggestion. Along the left side, I left some spherical shapes in their original charcoal-on-paper condition. On the lower right side, there is no defining of shapes at all. I wanted to leave a suggestion of the image fading off into nothingness in this area.

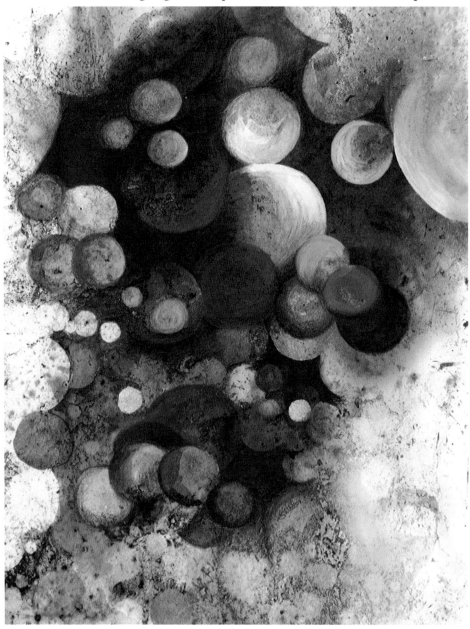

Bouncing Balls
By Cecilia Swatton
Mixed media
16" x 20"

Using acrylic paints, I covered Arches 140 lb. watercolor paper with a glaze of warm colors, orange-dominant. After that dried, I added a layer of cool greens and blues; quickly, while the top layer was still wet, I splashed the surface with rubbing alcohol. Once this was dry, I added more texture by using a variety of homemade stamps brayer-coated with semiopaque acrylic paints (mixable zinc-white blended with the same blues and greens previously used.) These stamps included thick, soft-foam puzzle pieces (from a children's toy store) which I had altered with rubber-stamp-cutting scissors. I used both sides of these altered puzzle pieces; one side created polka-dot patterns and the other produced smooth shapes.

I used the same stamps, with assorted acrylic paints, to alter translucent, medium-weight mulberry paper. When these papers dried, I cut them into various shapes which I added with acrylic gloss gel. I also added pieces of ultra-sheer white mulberry paper.

For acrylic paints and gels, Golden is my favorite brand. Golden colors produce the vibrant, rich, deep tones that most appeal to me. For the most part, I choose translucent paints, which enable me to overlap layers to yield the saturated fields of color I want.

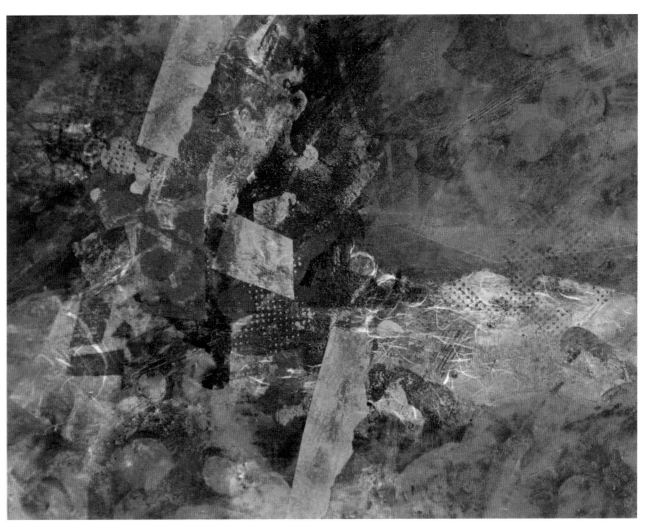

Orange Cruciform by Cecilia Swatton
Mixed media collage. 20" x 16"

Lynne Taetzsch

First I stretched Jerry's Artarama unprimed 12 oz. cotton duck on 1.5" thick heavy-duty stretcher bars, stapling the canvas on the back. This would allow me to continue painting the image around the sides so that it could be hung without additional framing. I gave the canvas a coat of acrylic gesso before beginning to paint.

Next I mixed a medium gray acrylic paint using Liquitex soft body paints, adding a little water and gloss medium. I painted the whole canvas in this gray including all the sides. After it dried thoroughly, I taped 2" strips of masking tape (painter's masking tape works best) across the canvas, two strips vertically and four horizontally. Then I painted the spaces in between with mars black.

After the black paint dried thoroughly, I stripped off the masking tape, leaving a background grid of black and gray. My next step was to paint a rough design in the same medium gray and a darker gray.

Once the canvas was dry, I used Liquitex hard body paint in tubes, screwing a cap to the end that allowed me to "draw" lines as thin or thick as I wanted. I drew lines in medium gray and cadmium red medium, creating additional horizontal grid lines, which I then flattened (thickened) with a brush. I also drew leaf shapes and other designs across the canvas.

When the paint was completely dry, I filled in the petals using iridescent silver and the red mixed with gloss medium to make it translucent. After that, I toned down some of the red with gray. I kept the top layer of paint thin and translucent so that the underlayers would show through.

My goal in painting is always to keep the composition loose, using the gesture of making a brush stroke or a line to energize the image. I like to create chaos, and then find order in that chaos.

My final step was to bring together background and foreground by drawing black lines around some of the petal shapes in a very loose way, creating a counterpoint to the images already there.

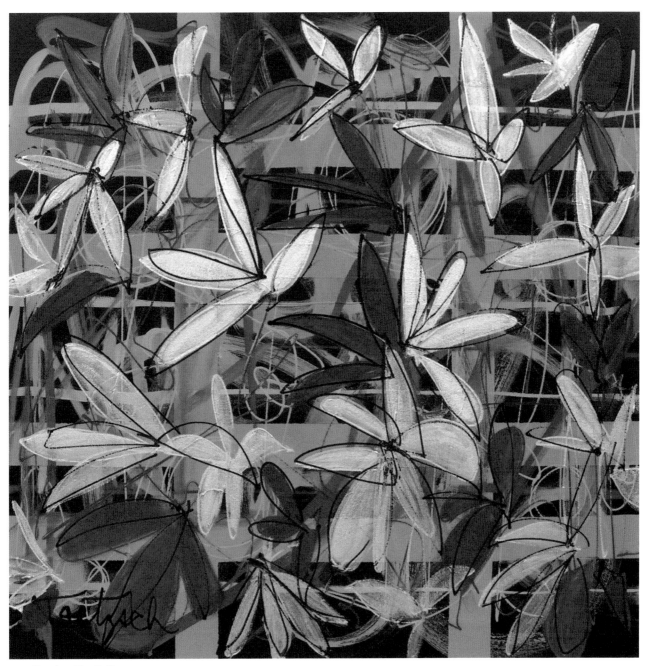

Parsing the Fullness
By Lynne Taetzsch
Acrylic
30" x 30"

Beverly Taylor

After years of working figuratively in watercolor, charcoal, and other drawing media, as well as printing etchings and monotypes, my venture into abstract art work came via collage combined with encaustic media.

Untitled began with unfinished watercolors I had kept over the years in my flat files because there was something about them I liked – line, color, texture. My preferred watercolor paper was Lanaquarelle 140 lb. hot press, but some older work was on Arches 140 lb. cold press.

I began by tearing the work in strips. I then carefully tore away the white, unpainted side of each edge. On a cradled birch board I began arranging the pieces, moving them around with an eye for color, texture, and line to develop a pleasing result. Much of my work was figurative, and because the eye is always drawn to the human face, I took special care to hide any faces to keep the end result abstract.

When I had an idea of the layout, I began to assemble the piece starting on the edges. Working on newsprint, I painted the back of one piece at a time with Lineco neutral Ph adhesive and placed it. I used a brayer to roll out any air pockets and make sure that the piece adhered well to the wood. I continued working my way across the surface making decisions as I went with attention to a variety of sizes and shapes, as well as color and texture. It was something like working a puzzle.

When I had the surface covered, I spent some time looking at the piece, turning it around and studying it. I added a few graphite lines to continue some that were already there. When I was happy with the piece, I used a flat file to bevel the edges and remove any paper that extended beyond the edge of the board.

I then melted encaustic medium to apply to the surface. I use a medium manufactured by R&F paints. It is made of beeswax combined with damar which causes the beeswax to harden. I brushed on a layer of the melted wax and followed by heating with a heat gun. It is important to heat each layer of wax as it is applied. (Encaustic actually means "to burn in"). I followed with more thin layers of wax and melted them in until I was happy with the look.

Because I wanted it to be possible to hang the piece more than one way, I signed the piece on the side before applying the encaustic medium to the birch cradle. By finishing the sides this way, the piece would be finished without further framing.

Untitled
By Beverly Taylor
Watercolor / Mixed Media
4" x 14" x 2"

After years of working figuratively in watercolor, charcoal, and other drawing media, as well as printing etchings and monotypes, my venture into abstract art work came via collage combined with encaustic media.

Hide and Seek began with unfinished watercolors I had kept over the years in my flat files because there was something about them I liked – line, color, texture. My preferred watercolor paper was Lanaquarelle 140 lb. hot press, but some older work was on Arches 140 lb. cold press.

I began by tearing the work in strips. I then carefully tore away the white, unpainted side of each edge. On a cradled birch board I began arranging the pieces, moving them around with an eye for color, texture, and line to develop a pleasing result. Much of my work was figurative, and because the eye is always drawn to the human face, I took special care to hide any faces to keep the end result abstract.

When I had an idea of the layout, I began to assemble the piece starting on the edges. Working on newsprint, I painted the back of one piece at a time with Lineco neutral Ph adhesive and placed it. I used a brayer to roll out any air pockets and make sure that the piece adhered well to the wood. I continued working my way across the surface making decisions as I went with attention to a variety of sizes and shapes, as well as color and texture. It was something like working a puzzle.

When I had the surface covered, I spent some time looking at the piece, turning it around and studying it. I added a few graphite lines to continue some that were already there. When I was happy with the piece, I used a flat file to bevel the edges and remove any paper that extended beyond the edge of the board.

I then melted encaustic medium to apply to the surface. I use a medium manufactured by R&F paints. It is made of beeswax combined with damar which causes the beeswax to harden. I brushed on a layer of the melted wax and followed by heating with a heat gun. It is important to heat each layer of wax as it is applied. (Encaustic actually means "to burn in"). I followed with more thin layers of wax and melted them in until I was happy with the look.

Because I wanted it to be possible to hang the piece more than one way, I signed the piece on the side before applying the encaustic medium to the birch cradle. By finishing the sides this way, the piece would be finished without further framing.

Hide and Seek
By Beverly Taylor
Watercolor / Mixed Media
14" x 14" x 2"

Susan Turconi

I have worked in a home studio my entire life. In the beginning, it was a closet. Now it's a room of my own. I have supplies on hand such as 40" x 30" canvasses and same size two-ply mat board which I use to develop ideas when I'm stuck.

I prefer Golden paints and gesso but have used just about anything on sale or handy in the heat of the moment including house paint, pastels, pencils, crayons, chalk, inks, markers, dyes, coffee, tea, and even hair dye!

I don't use brushes often, only when necessary for some detail. Abstraction gives free rein to spontaneity which can get lost with a brush in hand. I prefer those sponge on a stick tools, rollers, rags and my gloved hands. This painting simmered a long time waiting for me to get in the zone. Finally the day came and I was prepared.

Quick, break the white! (my mind is racing while I stare at the canvas). With pastels, and water, I spread pigment around searching for a form, shape, and lines. I use both hands many times because it will dry differently and I don't want to lose the intensity of the first application.

My first black swan memory was of a very aggressive creature landing on a Florida lake and gliding in as if on water skis. After seeing the award winning film, "Black Swan", the initial memory came back. I searched for some earlier drawings and renderings, and was amazed that the visual imprint in my brain was so much stronger which added to the challenge.

I started by breaking the white surface. I put gloves on and spread some color mixed with gesso around. I like to make a thick surface and spread it around with cake spatulas. Sometimes I will add premixed patching plaster and or a variety of media which I keep on hand but not today. My palette is limited: variations of red, yellow and blue along with umbers and sienna, black and white.

I stepped back to get a look and didn't like what was going on in the center, too soupy, so I waited for it to dry and then got the black gesso out. I always say when all else fails, there is always geometry. I created a few shapes with the gesso and yes, I did use brushes on the curves, added some color and was almost there. I spend some time just looking at it. I turn the painting sideways, upside down, hold it in front of a mirror and finally realize it needs a hint of texture which I quickly scribble on with colored pencil.

Every artist should have a sensor in their work space that screams, "Stop!" Perhaps a flashing light would be better. In any case, all one has to do is start first and then contemplate when to stop.

Black Swan Running
By Susan Turconi
Acrylic and mixed media on gallery wrap cotton canvas
40" x 30"

Liz Walker

This canvas began as a cadmium orange/pyrrole red-toned acrylic underpainting, a seated figure that I had started and abandoned. A few months later, I decided to marble over it in acrylics, not quite knowing how it would turn out. I figured I had nothing to lose.

For those unfamiliar with acrylic marbling, it's best to take a class before trying it on your own. There are lots of supplies and tools (best purchased via mail order) that you have to familiarize yourself with before you get started.

I was fortunate to take a local class which got me hooked on the marbling technique. Marbling is best done outdoors in mild weather under a covered area so that the paints and marble bath aren't exposed to too much heat or humidity. Outdoors is best because each marbled paper or object needs to be rinsed with the garden hose and hung on the line to dry. It's like doing laundry—but much more fun!

I prepared the carrageenan (a thickening agent derived from seaweed) in my blender and poured it into a 19" x 27" x 3" plastic tray (the marble bath). I then selected the acrylic colors I wanted to use - Utrecht brand works best,

thinned with water in a jar. To compliment the orange/red underpainting, I chose turquoise, white and red, and flicked these colors into the marble bath using plastic broom strands. As the droplets spread to form a stone pattern (achieved by adding a tiny amount of liquid ox gall to each color), I liked what I saw and decided to dip my canvas into the marble bath.. To my delight, the orange underglow of the canvas provided a beautiful backdrop for the red/white/aqua stone pattern that I marbled on top.

After rinsing the canvas (necessary to remove all traces of carrageenan) and letting it dry, I evaluated it in my studio and used a Caran D'Ache crayon to develop subject matter on top. The roundness of the shapes reminded me of rocks, and then pears. I drew in the various sizes and shapes of pears, considering foreground and background and aiming for overlapping shapes. I then set about to negatively paint a mixture of violet and red around the pears to set each one off. I did some direct painting on the pears trying to further enhance the aqua and orange stone patterns.

Speckled Pears
By Liz Walker
Acrylic Marbling
18" x 24"

Carolyn WarmSun

I love telling you about this because it was such an accidental and exciting process! One of those times when nothing I had planned worked, but several unplanned "accidents" made the piece.

I started out by cutting rock and stalactite and stalagmite shapes out of plaster gauze and placing them on the paper—the "rocks" on each end and the projections more toward the center. I was creating yet another cave wall for rock art for my Honoring First Artists series. I liberally sprayed the plaster gauze with water. When it was dry I pulled off the gauze, which left plaster in the shapes I wanted.

But when I began to paint, the shapes all disappeared! I kept adding paint, wondering where the plaster went. I was using the Dr Ph. Martin hydrus fine art liquid watercolors: iron oxide, paynes gray and burnt sienna. Since my shapes were gone, I did a quick adjustment and began to paint a cave wall with a darker recession in it—hoping to perhaps salvage the piece.

I had the paper covered with color and decided this wasn't working at all. It was too cold to go out to the patio to hose it off, so I put my butcher tray on the table, propped it up in the tray, and began spraying it with water from my garden shop sprayer. And it began to run in strings.

I stopped and watched what was happening. I lowered the paper so it did not all wash off. I loved it. Somehow, by a chemical process I do not pretend to understand, the paint ran in such a beautiful way that my cave wall looks like one where years of moisture has modified its surface.

All I had to do from there was paint the ubiquitous concentric circle design that is found on rocks, walls, and caves throughout the world. The "strings" allowed me to place the rock art behind—creating even more mystery.

This kind of process excites me the most—co-creating with my materials such that we end up traveling in surprising directions, ending the journey mostly very satisfied.

Honoring First Artists #23
By Carolyn WarmSun
Watercolor and acrylic on Arches 140 lb. CP watercolor paper
15" x 22"

This painting began as a terrible watercolor of a southwest landscape. Since I use primarily Dr. Ph. Martin Hydrus fine art liquid watercolors, the reds, purples, blues and yellows were INTENSE. My goal has been to "reclaim" and "repurpose" my busted plays.

I started by covering the surface with white gesso. I had not yet discovered Daniel Smith's superior gesso, so it was a thinner and less pigmented brand. I needed two coats to calm down the colors underneath. While the second coat of gesso was still very wet, I took the bag in which a 5-pack of Arches full sheet watercolor paper came placed it on the gesso and smoothed it with both hands. The board on which my painting was attached was in the landscape mode—this will be relevant in a moment. In smoothing the plastic on the gesso, it is impossible not to have wrinkles and marks. You want these! I then took the plastic sheet off, slowly, lifting and lowering as I went in order to get more marks. Because I lifted the plastic off with the painting in landscape mode, the slow lifting and lowering created marks that ran horizontally.

I took a long look at the piece to see what I now had to work with: a softly glowing underpainting, veiled with white, with interesting markings and lines. But when I turned it to portrait orientation I couldn't believe what was there—a gorgeous huge bare-limbed white tree. It took me two days of looking at it to believe what I was seeing.

I decided such a gift needed to be accepted. So I minimally enhanced the white lines of the tree trunk and branches with titanium acrylic, enhanced some of the red and blue within the lines of the tree, added a little shadow under some of the branches. And it was finished.

Since then, I have used this process and at least twice have gotten an incredible painting with good design and composition and abstract subject matter. Not always, but I at least get something that inspires and spurs me to a painting. It is an easier way for me to work—the stark and unblemished surface makes knots in my stomach. An altered surface stirs my imagination. So I am altering surfaces as a way to start my creative process.

Sometimes there is a magic—like the appearance of this tree.

Tree in Winter Fog by Carolyn WarmSun
Watercolor and acrylic on Arches 140 lb. CP watercolor paper. 30" x 22"

Margaret Watts

This piece began as a simple line drawing done after viewing the ghostly Marfa, Texas lights. At night, spheres float above the Chinati Mountains, viewed from a distance in Marfa. Colors move through the spheres, white, yellow, orange, red, and then faint blues and greens. This was truly a weird and wonderful visual experience; perhaps it is a mirage caused by abrupt temperature changes at high altitudes, In any case it ignited this painting.

I transferred my line drawing of the scene on a light box to Fredrix pre-stretched primed canvas with crayons serving as a resist. I blocked the main foreground shapes (insect parts, spheres) with Vaseline. I then outlined these shapes with thick white latex in hair dye containers and thinner white latex in an oiler to create little moats or raised lines around the shapes. After thorough drying, I painted, poured and sprayed (water in a fine mister) highly pigmented flat latex paint with first the primary colors, red, yellow, blue. As I painted the colors and sprayed with water, greens, blues, pinks, and ochre appeared. The moats or raised lines cause the paints to spread creating new shades and shadows.

After this layer dried, I lightly misted the entire piece with water. To differentiate layers, I used a flattened round brush and applied black latex to the mid and foreground shapes allowing the background to recede. Then I darkened and dulled the mid and background shapes with complementary colors.

After this surface was completely dry, I poured boiling water over the piece until all of the Vaseline disappeared. Vaseline residue leaves an interesting and lasting sheen on the colors. Several pouring's of boiling water were necessary to remove traces of the solid Vaseline. When completely dry again, I sealed the piece with water-based polyurethane. When this was completely dry, I lightly sanded the surface with a fine electric sander cleaning the surface with alcohol. The trick here is to assure that the layers are completely dry, several hours at the least.

The final touch was to paint the focal shapes white (this time white gloss latex) in the foreground. I varied the thickness of the paint so that previous colors (primarily light blues and pinks) could show through. I sealed with another coat of water-based polyurethane, sanded lightly, cleaning with alcohol, and then I applied the final coat of polyurethane.

This finishing touch gives the piece depth, mystery, and a special glow. It is currently on display at maggy mays, 126 Main St., Bay St. Louis, MS.

Night-Spirits
By Margaret Watts
Mixed media on canvas
24" x 30"

Susanne Werner

I always stretch my own canvases over frames my husband builds for me. At this time I "gallery-wrap" all my canvas on 2" frames. The canvas is not coated with gesso when I stretch it; I gesso the painting surface at least twice after it's stretched.

Then I start by randomly applying some of the colors I have selected for the painting. After this first layer is dry I start applying layers of Japanese rice papers such as Washi or Unrui using only white and natural shades. I buy the rice paper in sheets, but tear them into pieces about 4 x 6", No exact size is necessary, as the randomness adds interesting textures. I like lots of texture in the papers I use, like grasses, bits of leaves, pieces of string. The paper is applied with matte medium in no particular order, mixing patterns and shades as I go along.

Once the surface is dry after the rice paper application I start with a first layer of paint. It is very much a process of action/reaction. My approach is intuitive. I do not work from sketches, and make no attempts at literal representation. Observations I have made are transformed into shapes and forms. I translate and abstract the contemporary experience of life into visual language that goes beyond words. I like the viewer to respond emotionally to the abstracted shapes, colors, and textures. The process begins with the initial application of paint and continues as I react to subsequent layers; it concludes when an action no longer evokes reaction.

In between layers of paint I apply generous coats of matte medium. This gives the paintings depth. I may decide to add glass beads or sand for texture to parts of the painting. I may also use parts of old photographs, letters, corrugated cardboard, torn watercolor sketches or anything else that may add interest and texture to the painting.

The final step is to cover the exposed sides of the canvas with paint. Then I add a finishing coat of protective varnish to all parts, including the sides of the painting.

Mediterranean Sunset by Susanne Werner
Mixed media

I always stretch my own canvases over frames my husband builds for me. At this time I "gallery-wrap" all my canvas on 2" frames. The canvas is not coated with gesso when I stretch it; I gesso the painting surface at least twice after it's stretched.

Then I start by randomly applying some of the colors I have selected for the painting. After this first layer is dry I start applying layers of Japanese rice papers such as Washi or Unrui using only white and natural shades. I buy the rice paper in sheets, but tear them into pieces about 4 x 6", No exact size is necessary, as the randomness adds interesting textures. I like lots of texture in the papers I use, like grasses, bits of leaves, pieces of string. The paper is applied with matte medium in no particular order, mixing patterns and shades as I go along.

Once the surface is dry after the rice paper application I start with a first layer of paint. It is very much a process of action/reaction. My approach is intuitive. I do not work from sketches, and make no attempts at literal representation. Observations I have made are transformed into shapes and forms. I translate and abstract the contemporary experience of life into visual language that goes beyond words. I like the viewer to respond emotionally to the abstracted shapes, colors, and textures. The process begins with the initial application of paint and continues as I react to subsequent layers; it concludes when an action no longer evokes reaction.

In between layers of paint I apply generous coats of matte medium. This gives the paintings depth. I may decide to add glass beads or sand for texture to parts of the painting. I may also use parts of old photographs, letters, corrugated cardboard, torn watercolor sketches or anything else that may add interest and texture to the painting.

The final step is to cover the exposed sides of the canvas with paint. Then I add a finishing coat of protective varnish to all parts, including the sides of the painting.

Seattle Reflections
By Susanne Werner
Mixed media

Silvia Williams

I began with a quarter sheet of Arches 140 lb. watercolor paper. I wet the surface of the sheet and flowed the colors on the paper. I observed the movements of the paint as it spread. I used diluted watercolors of ultramarine blue, cobalt blue and medium yellow, letting the blues predominate. I let the paper dry and proceeded to the second stage.

In the second stage I began to think about the composition and decided to use a version of the cross composition. I then began to tear pieces of handmade and collage textured paper in compatible colors. I placed the torn pieces on the surface until I was satisfied with the composition.

The next step was to correct the values by adding color in the various spots where needed and adding any other collage pieces that were needed.

In the final stage, I made black ink lines to bring about a coherent composition. I also added other lines in white titanium to complete the work.

Because the work seemed ornamental, I entitled it Baroque Song.

Baroque Song
By Silvia Williams
Watercolors with collage
12 x 14"

Janet P. Wright

In the fall of 2010, an artist friend shared the secret ingredient in many of her paintings and crafts: using a household cleaner, Citra-Solve, she dissolves the vegetable-based ink used in current National Geographic magazine articles (not the advertisements), and creates fascinating paper textures to use as collage. Several months later, I had a couple of unscheduled hours so following her instructions I produced my own exotic textured paper.

Several more weeks went by before I had a chance to try it out. I'd painted a watercolor abstract which really didn't go anywhere so I decided I might as well paint over it to experiment with this process. I'd done a little collage but rarely used it in my work, preferring watercolor on Arches paper without any other materials. I generally use a cruciform design and begin by choosing a point about six inches from the interior edges of two of the quadrants to begin developing some background shapes. I repeat those shapes, using large, medium and small repetitions until I've built a bridge to some point on each of the four borders. Then I ask myself, "Is the overall shape grounded?" If not, I continue to embellish the shapes until I feel the "skeleton" of the design is in balance. After that, the real fun begins: I start elaborating on what will become the center of interest. Sometimes an accidental mark becomes a motif and I repeat it in different sizes in various parts of the painting, repeating values and colors to increase the linkage among the disparate shapes.

Dancing to Oblivion by Janet P. Wright. Watercolor and Collage. 22" x 30"

So, for the first time, I began tearing small pieces of some of my interesting pages in colors that harmonized with the palette that I'd chosen for my painting, and placed them into the painted areas in such a way that they would become seamless accents and harmonize with the overall design. I found that it was important to work with small, torn, not cut, pieces, overlapping and gluing them down with diluted craft glue. I like to be very precise in the details of my paintings while keeping the big picture loose and free. I really enjoyed this process, working back and forth between gluing collage and adding more painted detail.

When I stepped back to examine the result, I felt the corners seemed weak and I remembered a lovely still life I'd seen in a magazine recently with a black background. "Why not", I thought. "This is just an experiment on top of an old painting anyway." After filling in large dark shapes in several places at the edges of the paper, I noticed that the result reminded me of a meteor spinning in space. I added some small shapes, collaged on top of the black, to unify the painting. I was thinking about the real borders of the painting as the edge of the interior design and the black shapes extending the boundary between the piece and the exterior mat and frame. Hence, my "Space Place" series was born.

Since then, I've done a dozen of these full sheet "space places" using the same process although working with an intentional underpainting rather than using an unresolved one. It's so much fun I have to discipline myself to shift back to other types of painting production. I've also produced a number of mini-paintings using this process which have sold very well.

There is a sort of "yin/yang" motion in this process: first paint, then collage, then paint, then collage, although the collage material never exceeds 20% of the total painting. Often it's much less. Sometimes I try to precisely reproduce the pattern from the paper with my brush so the viewer is unable to detect the shift from one medium to the other. This also works when I run out of a certain texture and have to "invent" enough to finish an area. I'll continue in space until something calls me elsewhere. Tomorrow the moon!

Sailing to Byzantium by Jan P. Wright
Watercolor and Collage. 30" x 22"

Ed Zey

My artistic concepts come from a number of sources – my studies of art and artists' work and technique; my past experiences including 37 years as a research scientist; and my interest in philosophy and technology. I focus on seeing things in new ways.

This painting started as a concept in 1997 and was reduced to a drawing in Journal Book No. 7, p.12, Jan 2, 1999. My journal entries were and still are used as a first step in my abstract art creation. This entry (on 3.5 x 5 in., 60 lb paper) is a convenient method for documenting, reviewing and comparing new and adjacent ideas.

The journal process described above involves placement of basic structural lines consistent with the abstract image in my mind, followed by finer lines to further the concept. At this point, a first attempt is made to supply a title for the drawing. I move as quickly as possible, balancing the image and title, and let the art work just flow. Feeling is more of a guide than understanding.

The next step in the process involves scaling up the drawing to the desired paper size. This scale-up usually involves the use of transfer co-ordinates which allows me to see and add new elements of creativity to the work. At this time I also take a fresh look at the title along with additional meanings analysis.

I am currently completing a large body of work in final form. Evidence of Change is only one such work. My art has been an exciting adventure with new ideas continuously emerging.

Evidence of Change by Ed Zey
Black Ink on Paper. 8.5" x 11"

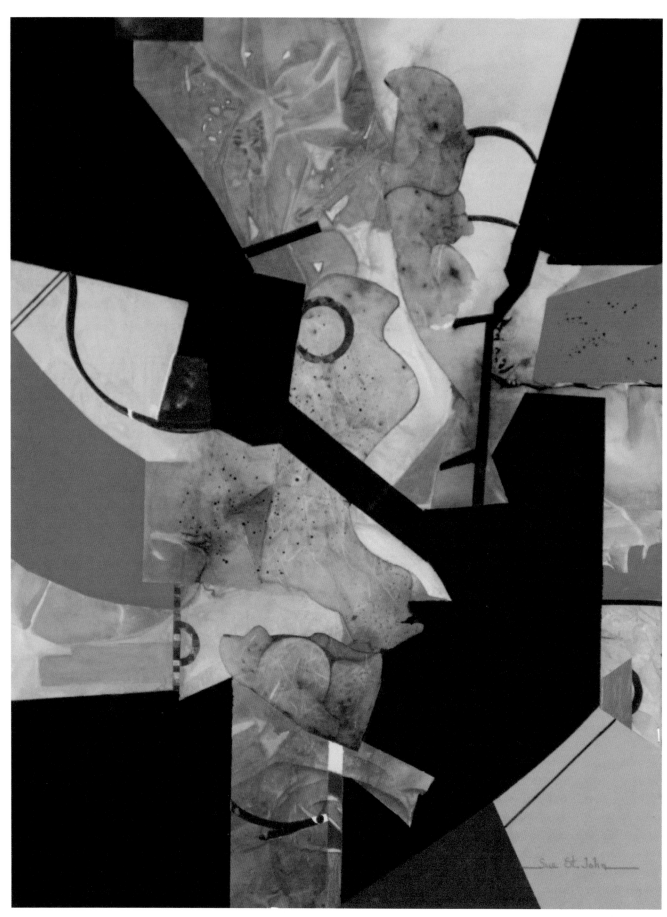

Bird's Eye View by Sue St. John, AWS. Mixed media, 30"x 22"

DIRECTORY OF ARTISTS

Jacqueline Doyle Allison
jacquelineallison@att.net
www.jacquelineallison.com

Denise Athanas, AWS, WHS
Mt. Pleasant, SC 29466
deniseathanas@comcast.net
www.deniseathanas.com

Lynne Baur, MnWS
Hudson, WI 54016
lynne@dragonflyspiritstudio.com
www.dragonflyspiritstudio.com

Lisa B. Boardwine, BWS
Grundy, Virginia 24614
boardwinelkb@yahoo.com
www.facebook.com/lisabboardwineartist

Mickey Bond
Sante Fe, NM 87505
mickeybond505@aol.com
www.mickeybond.com

Todd Breitling
Wilmington, DE 19803
tbreitling@verizon.net
www.toddbreitling.com

Martha Brouwer
marthabrouwer@gmail.com
www.marthabrouwer.com

Carol Carter
St. Louis, MO 63104
carol@carol-carter.com
www.carol-carter.com

Katy Cauker
Jacksonville, OR
katy@katycauker.com
www.katycauker.com
katycauker.blogspot.com

Elizabeth Chapman
Springfield, MO 65803
elizabethchapman@artlover.com
www.melizabethchapman.artspan.com

Susanne (Sue) Darius
Chilliwack, BC
sdarius@shaw.ca
www.suedarius.com

Jan Hunt Dawson
Larkspur, CO 80118
janhuntdawson@gmail.com
www.jnahuntdawson.com

Sue Donaldson
sue@suedonaldson.com
www.suedonaldson.com

Joan Dorrill, ISAP
St. Augustine, FL 32080
jodoart@bellsouth.net
www.JoanDorrillArt.com

Autry Dye, FWS, TWS, WSA
Gulf Breeze, Florida
autrydye@bellsouth.net
www.autrydye.com

Kristi Galindo Dyson, NPS, Juried member
of Women Painters of Washington
Renton, WA 98058
galmoose@comcast.net
www.womenpainters.com (see members bios)

Joan Enslin, NWWS
Camano Island, WA 98282
jjcamano@gmail.com
www.joanenslin.com

Kay Fuller
Washington, DC 20003
Cfuller432@aol.com
www.kayandbobfuller.com
www.kayfullerart.blogspot.com

Joan Fullerton, SLMM
Parker, CO 80134
joan@joanfullerton.com
www.JoanFullerton.com

Judy Gilmer, ISAP
Daytona Beach, Fl 32141
judith@gilmer.com
http://www.judygilmer.com

Madelaine Ginsberg

Sue Hamilton
Reston, Virginia 20191
schamlton@aol.com
suehamiltonart.com

Karen Hansen
Burbank, CA 91504
Karen@KLHansen.com
www.KLHansen.com

Kathryn Hart, NWS, NAWA
Larkspur, CO 80118
kathryndhart@aol.com
www.kathryndhart.com

Cathe Hendrick
Jackson, Michigan
cuisshendrick@aol.com
www.cathehendrick.com

Susan Hensley
Blacksburg, VA 24060
Suehen2@hotmail.com
Artbysusan-hensley.blogspot.com

Carlynne Hershberger
Ocala, FL 34470
hershbergerhuff@hotmail.com
www.hershbergerhuff.blogspot.com

Donna Holdsworth
Portage, PA. 15946
Donna.holdsworth@yahoo.com
donnaholdsworthsartblog.blogspot.com

Terry Honstead
Bemidji MN 56601
honstead@paulbunyan.net
terryhonstead.wordpress.com
terry-honstead.artistwebsites.com
terry-honstead.blogspot.com

Tis Huberth, ISAP
Elected Member Women Painters of Washington
Auburn, WA 98001-1569
tiswatercolorsetc@yahoo.com
womenpainters.com (click on biographies)
lavincigallery.com

Bob Kevin
12002 Gladiolus Pt S.
Floral City, FL 34436
bobkevinartist@gmail.com
www.bobkevin.com

Judy Kramer
University Park, Florida 34201

Witha Lacuesta
1784 Independence Ave.
Viera, FL 32940
ralmail@earthlink.net
www.lacuesta-art.com

David Leblanc
Action Abstraction Studio
Lowell, MA 01851
actionabstraction@gmail.com
www.actionabstractionstudio.com

Jeffrey Levin
Jacksonville, Or
maclevin@charter.net
www.maclevinart.com

Monica Linville
Luquillo, Puerto Rico 00773
monica@monicalinville.com
www.monicalinville.com

Carol A. McIntyre, TWSA
Colorado Springs, CO 80908
carol@mcintyrefineart.com
PaintingHarmony.com

John McLaughlin
Canton Michigan 48188
drawinghermit@yahoo.com
www.drawinghermit.com

Catherine Mein
Virginia Beach, VA 23454
cmein@cox.net
www.catherinemein.com

Julie Elizabeth Mignard
Jalisco, Mexico
juliemignard@yahoo.com
http://www.julieelizabethmignard.com/

Joye Moon
Oshkosh, WI 54904
www.joyemoon.com
joyemoon@northnet.net

Kathleen Mooney, NWS, ISEA-NF
Lowell, MI 49331
Fire and Water ART! Gallery
kmooney@iserv.net
www.kathleenmooney.com
Facebook - Kathleen Mooney Artist

Roberta Morgan

Patricia Oblack
Glencoe, MO 63038
patty@patriciaoblack.com

Dr Craig Peck (CWP)
Gordon's Bay
Cape Town, South Africa, 7140
+27 (0) 21
doccwp@gmail.com
www.wix.com/peckasso/dr_cp

Lee Pina
ynham, MA 02767
Lee@LeePina.com
LeePina.com

Isabella Pizzano
Denville, NJ 07834
Isamari7@aol.com
www.isamari.com

Susan Prinz
Floral City, FL 34436
susanprinz@gmail.com
www.susanprinz.com

Barbara Ragalyi, SLMM, NAWS
Sedona, AZ 86351
b.ragalyi@esedona.net
www.ragalyiart.com
www.barbara-ragalyi.blogspot.com

Gayle Rappaport-Weiland
Rocklin, California 95765
gayle@grappaport.com
www.grappaport.com
www.facebook.com/grappaportfineart

Sue Reynolds
webstee@susanreynolds.com
www.susanreynolds.com

Jane Robinson
Jackson, MI 44201
janemrobinson@comcast.net
www.janerobinsonabstractart.com
www.artepicureun.blogspot.com

Kathy Blankley Roman
Chicago, IL 60618
K.B.RomanArt@gmail.com
www.facebook.com/KBRomanArt

Chris Romine
Bellingham, WA 98229
rominestudios@comcast.net

Judy Lyons Schneider
Lakewood Ranch, FL 34202
JLSArtStudio@aol.com
www.judyschneider.artspan.com

Eric Harley Schweitzer
Chevy Chase, MD 20815
Studio address:
6925 Willow Street, N.W. #207B
Washington, DC 20012-2000
www.schweitzersart.com

Alan Soffer
Wallingford, PA 19086
allthreads@comcast.net
www.alansofferart.com

Pat Stacy
patstacy@gmail.com

Cecilia Swatton
Greater New York City Area
www.ceciliaswatton.blogspot.com

Lynne Taetzsch
Ithaca, NY 14850
lynne@artbylt.com
http://www.artbylt.com

Beverly A Taylor
Bellevue, WA 98004
bataylorarts@comcast.net

Susan K. Turconi
Venice, Florida 34285-6441
susanturconi@hotmail.com
www.womencontemporaryartists.com
(scroll to
members)

Liz Walker, NWWS
Portland OR 97229
lizartist@comcast.net
www.lizwalkerart.com

Carolyn H. WarmSun
Oakland, CA 94611
cwarmsun@sbcglobal.net
www.warmsunart.com

Margaret Watts, Associate Member Society
of Layerists in Multimedia
Aurora, CO 80015
Info@margaretarts.com
www.margaretarts.com

Susanne Werner, Juried member of Women
Painters of Washington
Bellevue, WA 98006
swlovesart@gmail.com
www.womenpainters.com
www.parklanegallery.com

Silvia Cabrera Williams

Janet P. "Jan" Wright, TWS, MOWS
Claremont, CA 91711
jan@genger.com
janwrightfineart.com

Ed Zey
Fredericksburg, TX 78624

About the Author

Sue St. John has been painting for more than forty years. Like many Midwest artists, she began with painting rural landscapes, barns and flowers in oil. Having lived for several years in the beautiful hills of Brown County Indiana, this was natural.

Over the years Sue began working more in watercolors and moving toward more abstract paintings. She found the challenge of watercolors and abstracts to be a wonderful outlet for her creative talents. She loves abstract art where color flows freely giving the effect of stained-glass colors.

"We who create are very blessed to put something into this world that is totally and uniquely us," she says. "It completes the circle to be able to share it."

Sue is a Signature Member of the American Watercolor Society and a Signature Artists Member of the Kentucky Watercolor Society.

Dedication

This book is dedicated to my family whose unfailing love and support provides me a soft place to land.

Journeys to Abstraction 3.

Cover art includes images by Carol Carter, Katy Cauker, Judith Gilmer, Judy Kramer, Julie Mignard, Lee Pina, Barbara Ragalyi, and Weiland Rappaport.

Cover design by D.J. Natelson.

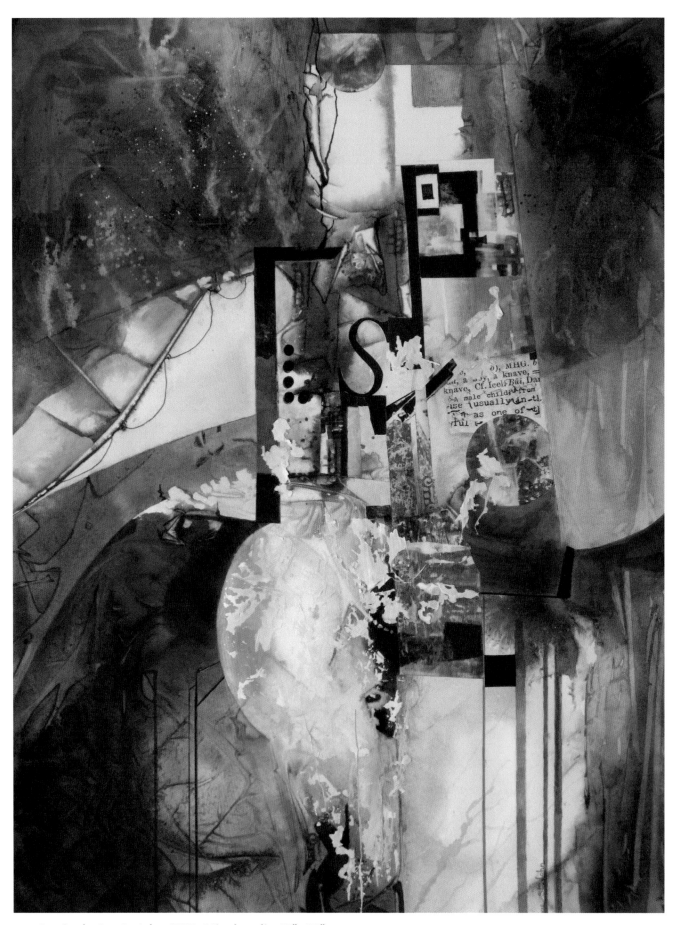

Destiny by Sue St. John, AWS. Mixed media, 30"x 22"

Printed in Great Britain
by Amazon